MASACCIO

C

ONTENTS

Stefano Borsi

Cover:
Masaccio
and Masolino,
Saint Anne Metterza
(c. 1424), detail;
Florence,
Uffizi.

Opposite:
Profile of a Young Man
(1423-1425);
Boston,
Isabella Stewart
Gardner Museum.

Right:
*Saint Peter Baptizing
Neophytes*
(1424-1425),
detail;
Florence,
Church
of the Carmine,
Brancacci Chapel.

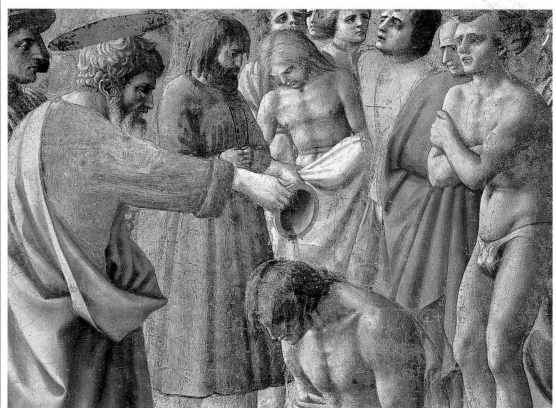

3

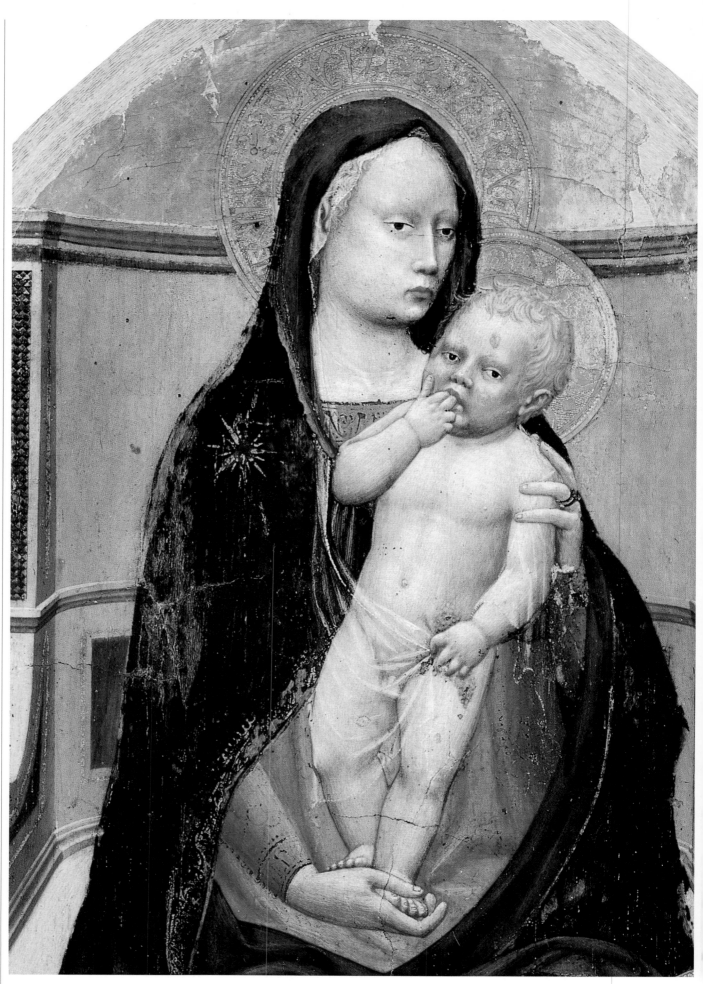

4

Masaccio, Masolino and the Others

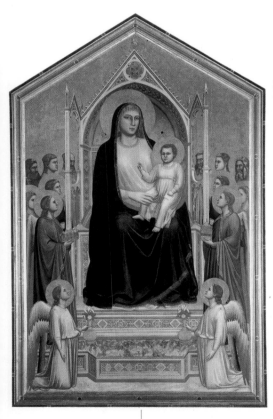

OMMASO (MASACCIO) was born in 1401, at the beginning of the new century, in San Giovanni Valdarno, a prosperous "terranuova" (new town) founded a century earlier by the Florentine Republic to protect and develop its southern dominions.

He was the son of a notary, like his friend Brunelleschi, but the wealth of his family soon diminished on account of his father's premature death (he also died around the age of twenty-seven and this coincidence suggests an inborn disease). Apparently, he had some problems during his youth: he had disputes with his relatives over heredity matters; his mother married again with a local tradesman; he had to accept the tutelage of the minors' tribunal of the time; his youngest brother, Giovanni, took his chances as a soldier joining when almost a boy the highly rated soldiery of the *condottiere* Braccio da Montone (who managed to lead a personal politics in Central Italy and gain support from Florence but found himself in opposition to the Papacy). Young Tommaso, on the other hand, immediately dedicated himself – perhaps on account of his poorer health – to an activity already carried out by his grandfather and, probably, by his ancestors as well: he was a chest painter, a *cassaio* or *cofanaio*, as this activity was termed then. In their joint tax-return (meanwhile, his brother Giovanni had devoted himself to painting: during his long life he developed an innovative style as a decorator, and was known under the name of "Scheggia" – splinter – probably because of his not particularly strong build), the two brothers declared to be «cassai in Firenze», thus contributing to create that surname by which they were generally called, Cassai (it seems that the name can be dated around that period while, just to make an example, a family of salted meat merchants had taken the name of Carnesecchi – dry meat – generations before).

We know nothing of Masaccio's beginnings in San Giovanni Valdarno; he moved to Florence when he was very young to take his chances at the end of 1417, soon after the fear to be infected by one of the frequent outbreaks of plague had gone. Around the same period, Mariotto di Cristofano, a painter from the same town as Masaccio, also moved to Florence; he later married one of

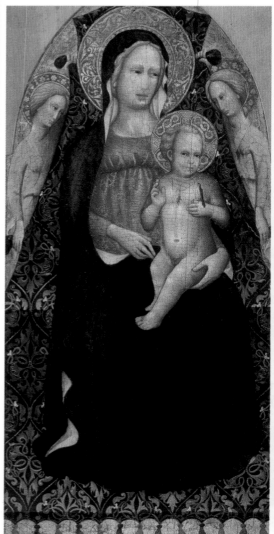

Masaccio's step-sisters, but nothing suggests there was any important collaboration between the two artists. Besides, as far as we know, Mariotto's later works show no sign of being influenced by Masaccio's novelties.

In 1418 Tommaso was in Florence and lived in the popular parish of San Niccolò in Oltrarno (the church was then under renovation). If we are still unable to appreciate him as an original master – as a matter of fact, we do not know any works by him datable before 1422 – it is, however, evident that his impact with the city was very stimulating and culturally enriching.

The Florentine painting of the time was extremely varied and cosmopolitan. The Spanish influences of the great Gherardo Starnina were not over yet (few of his works are still extant, because a great part of the famous fresco cycle of the Church of the Carmine were destroyed during the fire of 1771) and already a group of masters distinguished themselves for their freshness and novelty of style. They were the Portuguese Alvaro Pirez, Rossello di Jacopo Franchi, the anonymous – probably also from Valdarno – Master of 1419 (from the date written on his eponymous work), the Master of the Straus Madonna (from the owner of a panel on which the artist's list of works has been reconstructed). They all featured the enrichment, also on an international basis, of a pictorial style which had its roots in the Gothic world and which a stream of artists were bringing back, alternatively influencing or being influenced by their cultural *milieu*, and more open to external experiences. The new style was linked to a specific Florentine *quid* and to the undiscussed *auctoritas* of the great Giotto who, from the 13th-century world of guilds, had ascended, the only one and ahead of his times, to the role of "father of the language", the only one to be compared to the old masters, the first to be magnified by men of letters and to be placed permanently among the "illustrious men" of the city. Giotto, the new Apelles, was the only

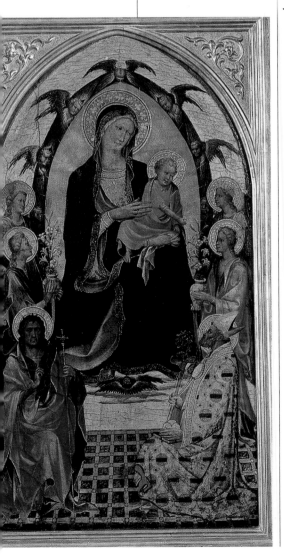

one who could be compared to the many Polycletuses who charmed humanists, collectors and sculptors who had the new century's ever-increasing passion for antiquities.

Masaccio, like all his Florentine colleagues, probably studied Giotto and his works: and it is he who, in a celebrated essay of 1896, Berenson describes as «Giotto born again», the new founder. It may even seem pointless to reason on Masaccio's "prehistory", who was described by Longhi in an even more celebrated essay, as a man *par excellence*, without prehistory. Clearly here is where the problem begins, if one aims at a better understanding of his remarkable pictorial culture – as yet not universally recognized – and his extraordinary novelty. A new look on Giotto, freed from old ways of considering him, which had existed for generations though they were still common at that time (groups of followers of Jacopo di Cione – the youngest of the Orcagna brothers – and Mariotto di Nardo were still active in those days, as well the followers, even more numerous, of Agnolo Gaddi, the son of Taddeo Gaddi, who had been a disciple and an original interpreter of the great Giotto); was the characteristic of Masaccio's position, ever since his beginnings, just when Brunelleschi studied the centres of production of Florentine Romanesque and Donatello did the same with Arnolfo and the two Pisanos.

However, to limit the search for the seed of future development in painting alone would undoubtedly be simplistic and not just for its evident methodological inadequacy, which shows a taste for simple evolutionism and banal "afterwit". Masaccio's unusual position – notoriously the only painter mentioned by Alberti in his dedication to Brunelleschi, composed for the treaty *On painting* – is to be seen considering other things as well. Obviously, it was not only late Gothic painting – we apologise for such a brutal, though easy, division – with its myths and problems, that characterized the artistic life of Florence of that period, and that, even less so, justified Masaccio's strong individuality and innovative purport. There were animated debates on monumental statues and the "ancient" themes on statues were resumed: those on reproductions larger than life-size, groups, bronze casting and ceramics. Renowned masters such as Niccolò Lamberti and the rising star of the beginning of the century, Lorenzo Ghiberti, had long been engaged in these debates when important public commissions were resumed. The Sienese Jacopo della Quercia and Francesco di Valdambrino who took part to the by then official "competition" of 1401 for the new doors of the Florentine Baptistry joined too. New protagonists participated as well, such as Brunelleschi, who had not abandoned his interests for sculpture and casting – actually, he had started working as a goldsmith – and the younger Donatello and Nanni di Banco. The concept of statue – like those for the bell-tower and the buttresses (it is certain that Brunelleschi and Donatello collaborated for their implementation) of Santa Maria del Fiore or those "sponsored" by the city guilds for the niches of Orsanmichele – entailed proportions, a relation with space, formal synthesis, attention to the viewpoint, optical corrections and so on: the artistic debate warmed up, the experiences followed up one after the other. It is unlikely that the young Masaccio, – who later continued to show an interest for the world of sculpture and who associated with Brunelleschi and Donatello – remained perfectly indifferent to it. Could he ignore Brunelleschi during the years in which he formed his style and started the huge undertaking of the Cathe-

Here above:
Lorenzo Ghiberti,
Sacrifice of Isac
(1401);
Florence,
Museo Nazionale
del Bargello.

Here below:
Francesco
di Valdambrino,
Saint Crescenzio
(1409);
Siena,
Museo dell'Opera
del Duomo.

dral dome which, as late as 1410, was at a standstill after the coping of the octagonal drum?

Brunelleschi's learned teachings on space, the problems of his sculptor friends, the discussions and experiences on perspective problems widened Masaccio's horizons. It has been suggested that he was first apprenticed to a sculptor, but no documentary evidence to support such a theory has been found (it is not certain, either, whether Masolino was one of Ghiberti's apprentices when he executed the Baptistry doors), though it is a possibility. However, this is not enough to explain Masaccio's personal style. It must be admitted that he was not an illiterate artist; this can be easily understood considering how confidently he chose and learned from his sources; his humble aspect, described by Vasari and in other sparse documents, should not mislead us: a shabby-looking man, who had run into debt to buy the few clothes he had, who was constantly harassed by his creditors, forced to execute some paintings of lesser value to pay his debts, like an *Our Lady* for a tabernacle sold to a furrier around 1426 and now untraced. He was also a rather learned man, able to apprehend a great deal from the men of letters he associated with, though there is no definite documentary evidence of this.

When he tackled the problem of History with his compositions on the walls of the Carmine, Masaccio searched deeply into its values and meanings like an experienced humanist with the moral austerity of a generation hardened by civil responsabilities during the difficult Republican period. «Aliud historia, aliud laudatio», history does not coincide with praise – stated the Arezzo chancellor Leonardo Bruni, one of the officially recognized intellectual and political *patres* of the

Here above:
Filippo Brunelleschi,
Sacrifice of Isac
(1401);
Florence,
Museo Nazionale
del Bargello.

Here below:
Donatello,
Saint Mark
(1411-1413);
Florence,
Orsanmichele.

Right:
Jacopo della Quercia,
*Tomb of Ilaria
del Carretto*
(1408), detail;
Lucca, Duomo.

Masaccio's training took place in the stimulating cultural atmosphere of early 15th-century Florence, which was the propelling centre of a new art, and at the same time the container of long-established traditions: it was the city of emerging Humanism, but also of enduring late Gothic traces, and which still had Giotto's teachings in mind. Masaccio stood before this context with an open attitude: he looked to the past and the present, to painting and sculpture, to Donatello's and Brunelleschi's ideas, which could reveal art's new frontiers.

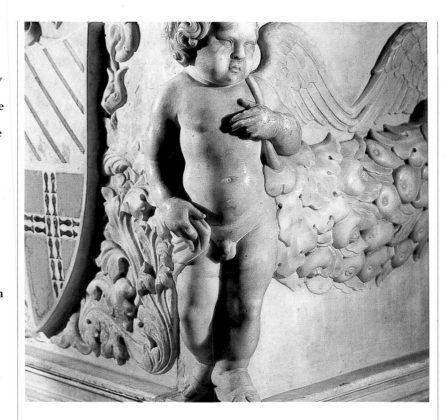

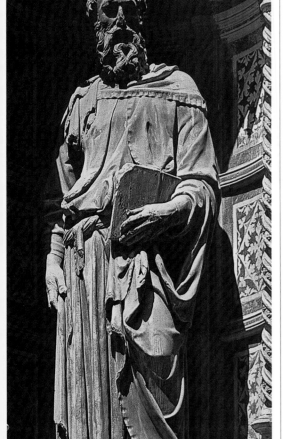

country, among the few who survived the sudden political changes which allowed the Medici family to go to power from the 1440s. Masaccio immediately eliminated the apologetic tones of a predictable and traditional hagiography from the Holy Scriptures, thus making a humanistic reflection on history.

In those years Florence has deserved the attention of famous scholars for its intellectual prosperity, its tangible wealth already described by Bruni in his *Laudatio florentinae urbis*, its complex institutions, its political and social problems: it is the city of Bruni's panegyric, with luxurious stone palaces belonging to ancient families and the revolutionary experiences of *avant-garde* artists. Florence received Pope Martin V who after the laborious reconciliation of the Western Schism of 1417 finally re-established the unity of the Catholic Church. The presence of the Pontiff attracted several artists from Central Italy enticed by the hope of finding good work opportunities with the Curia. Among others, there were two first-class artists: Arcangelo di Cola da Camerino, who later obtained a safe-conduct for Rome after having painted some panels in Florence and having seen Masaccio's beginnings, and especially Gentile da Fabriano, who received very important commissions in Rome, such as the frescoes for Saint John in Lateran. Florentine painting was immediately shaken, these leading presences were instantly felt, but during this period there were no works by Masaccio. Gentile, thanks to local prestigious commissions, revived the splendours of a rich style and a refined, studied technique with highly descriptive tones, an exuberant and encyclopedic naturalism as in the Lombard notebooks. After having won the favours of the local richest patron – Palla Strozzi, who later became Felice Brancacci's father-in-law and who ended up by involving him in his political ruin – Gentile da Fabriano exercised, thanks to his sudden success, an undiscussed leadership on the Florentine (and also Sienese) painters. Amongst them Masolino whose vicissitudes became interwoven with Masaccio's in a still obscure way.

9

First, it must be said that Masolino's beginnings are still mysterious and can only be reconstructed on indications, because works prior to the 1423 *Madonna* in the Kunsthalle Museum (Bremen) are wanting: by this date, Masaccio was already well-known and had already found his own artistic path. A light would be cast on Masolino's early period by the highly refined *Madonna* (the former Contini Bonacossi *Madonna*), but there is no consensus over its chronology and attribution, though it is undoubtedly datable before 1423. Later works, such as the very much discussed *Annunciation* (ex- Goldman and Mellon, Washington, National Gallery) which Vasari attributed to Masaccio (1568), reveal Gentile's influence on Masolino, though there remained some significant differences and a certain autonomy. A more conventional figure, Bicci di Lorenzo, was at the head of a workshop which employed many artists, and which was able to accept important undertakings like the completion and decoration of the Florentine Church of Sant'Egidio. It was a fashionable workshop, where worked Masaccio's brother, Scheggia, and Andrea di Giusto who for some time was a follower and collaborator of Tommaso, and perhaps the latter himself, in a mutual exchange which will come to light in the Masaccesque cues in Bicci's paintings. Masaccio's earliest work, rediscovered by Luciano Berti at the beginning of the Sixties, is a rather recent acquisition. Confined in the little country Church of San Giovenale at Cascia near Reggello, in the surroundings of Florence, it had never been mentioned in the studies on Masaccio, nor by any source for centuries. The unsigned work is dated April 1422: the artist had only recently joined the group of Florentine painters. The typology and size of this triptych are rather conventional, however it reveals an independent and unique personality, so much so that any other attribution is not convincing. The triptych does not show much of Gentile's attractive and sumptuous style and after a rather clumsy start in a style similar to Bicci's (visible in the two saints in the left panel), the painter chose a path with a more consistent spatial *ratio*, until he achieved the final result of the central panel. The modifications in progress are one of the most peculiar characteristics of Masaccio; he rapidly passed from one experience to the other and lived his life at high speed, a couple of months were a very long time for him: he was like a meteor, and his activity came to an end in about six years.

In 1422, Masaccio (and perhaps Masolino, too) had the opportunity to be present at the Consecration of Santa Maria del Carmine, an event of great social and religious importance, which had been awaited for years. He was a significant character of the ceremony with his *Sagra*, now lost, frescoed in a lunette of the convent's first cloister; his acquaintances among the Carmelite environment, with its lay companies of painters which actively organized miracle plays – as it has been ascertained with regards to Masolino – can explain the contacts and opportunities he later had. This was the start of his peculiar collaboration with Masolino, though it is not clear exactly how and when it happened. He was from the same region as Masaccio, though he was many years older and had probably been active in town for some time as a painter who had matured in Starnina's group (he seems to inherit Starnina's type of patrons, both in Empoli and in the Church of the Carmine). Because of rather obscure circumstances, Masolino was late in joining the Florentine painters' Guild, and only did so after Masaccio, in 1423 (maybe attracted by Carnesecchi's important

Here above:
Giovanni
di ser Giovanni,
called Lo Scheggia,
Adimari Cassone
(1440-1445);
Florence,
Galleria
dell'Accademia.

**Born after
his father's death,
in 1406, Masaccio's
youngest brother,
called Lo Scheggia,
mainly painted
chests,
deschi da parto,
and other objects
for everyday use.**

Here below:
Bicci di Lorenzo,
*Madonna and Child
with Donor*
(1423-1426);
Empoli (Florence),
Museo
della Collegiata
di Sant'Andrea.

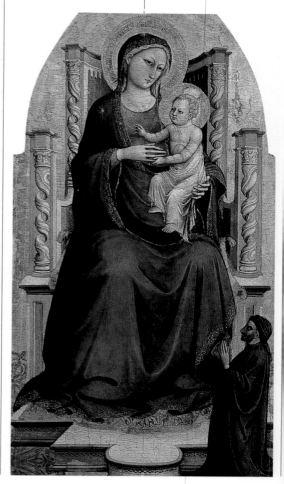

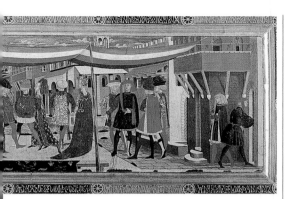

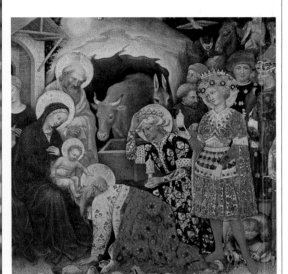

Right:
Masolino da Panicale,
Madonna of Humility
(1423);
Bremen,
Kunsthalle.

Left, at the centre:
Gentile da Fabriano,
Adoration of the Magi
(1423),
detail;
Florence,
Uffizi.

Here below:
San Giovenale Triptych
(1422);
Cascia di Reggello
(Florence),
San Pietro.

commissions?), thus remaining under his father's protection for a long time (did he need a trustworthy agent, foreseeing long stays away from Florence?).

It was a strange friendship, between a mature painter, whose father was also his manager, and a talented and independent orphan, but the little evidence existing is not enough to solve one of the most intricate problems of 15th-century European art history. The precedents are unknown, and when the two collaborated for the *Virgin and Child with Saint Anne* in the Uffizi (formerly in the Church of Sant'Ambrogio – another non-documented fact –) the relation already appears to be rather solid. The two artists divided up their work according to a pattern which is still very much discussed, with neither of them prevailing on the other; it is not ascertained whether Masolino was the only one who received the commission. Undoubtedly, Masolino had a *forma mentis* who pushed him to a hectic and erratic activity, naturally tending to have assistants around him, but it is not definitely proven that he only looked for them at a later stage, partly because he was anxious to complete his works. When Masolino sketched with a monumentality reminiscent of the 13th century the imposing and slightly hesitating figure of Saint Anne – whose extended hand is rendered in a foreshortened position which struck Leonardo – he was already in a condition to give his collaborator much more than a simple section of the panel: Masaccio did not intervene because his friend had abandoned the project, but worked at his side. He showed absolute vigour and volume synthesis on the sections he had been assigned, making use of light to represent three-dimensionality, something which characterize all his works. If a rational measurement of space seems to absorb Masaccio's interests, the soft fusion of colours proposed by Masolino (Vasari's «union») does not attract him very much, and the angel on the top right, the only one by Masaccio, can be distinguished from the others for the strong light and shade effects and for its sharper colour contrasts. One might say that their nicknames were not casual: Masolino was graceful and slender and Masaccio was more intransigent, described by Vasari in his biography as a tramp, while his model was an artist well introduced at court, who lived rich and respected under the protection of his patron. The debated chronology of the altarpiece once in Sant'Ambrogio does not help cast a full light on the "facts" of Masolino and Masaccio (an allusion to the title of the famous essay published by Longhi in 1940) who, around 1424-1425, were enriched by a series of works which have suffered the ravages of time. These are important paintings which have been lost, dispersed or dismantled and incomplete. The extant parts of the Carnesecchi Chapel, in Santa Maria Maggiore in Florence, decorations do not confirm Masaccio's participation to the project, as was suggested by Vasari in his *Lives*. On the contrary, more problems are added because of a lost wall decoration by the young Paolo Uccello, who was also away from Florence between 1425 and 1430; however, Masolino's leading role is confirmed.

Of the *Saint Ives of Brittany*, painted separately by the two masters (Masolino at Empoli and Masaccio at the Badia of Florence), only one fragment of the first and Vasari's mention of the second are left; it is a serious loss because it would have been an interesting opportunity to make a comparison, though the chronology of Masaccio's fragment, which disappeared well into the 17th-century, is still uncertain. The recurrence of this theme is an interesting

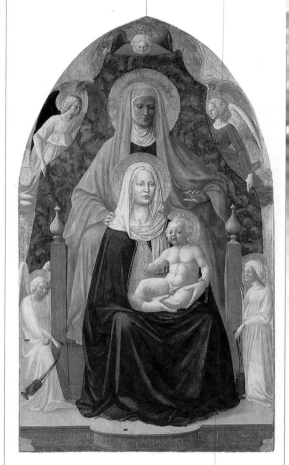

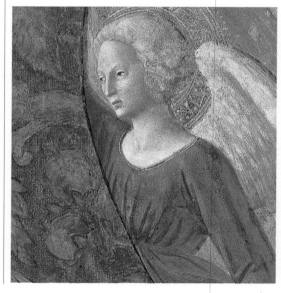

12

The relation which united the two great masters of Tuscan Quattrocento still remains obscure, both from the biographical and artistical points of view. This panel – now at the Uffizi, and once kept in the Florentine Church of Saint Ambrogio, according to what Vasari stated in the second edition of his *Lives* (1568) – is no exception to the usual rarity of documentary evidence. Vasari attributed the painting to the sole Masaccio, and experts maintained this view for a long time. In 1931, Lindberg was the first to suggest a collaboration with Masolino; a decade later, Longhi made a distinction between the contributions of the two artists, proposing a division of labour on which critics generally agree still today: Masolino probably executed Saint Anne and four angels; Masaccio painted the Virgin, the Child, and the angel holding the cloth of honour on the right. It has not been ascertained if the altarpiece was part of a triptych; perhaps it had already been dismantled when Vasari wrote about it in 1568.

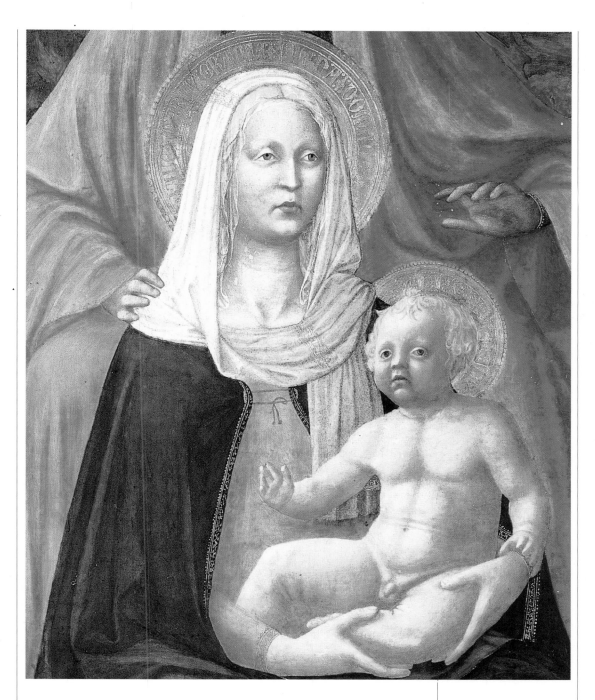

indication of the attention given to the Florentine social problems of the time: the saint is the protector of widows and orphans.

Also lost are the frescoes with the two Apostles Peter and Paul probably executed by the painters, according to what Vasari states, in the two pilasters of the Eastern arm of the Carmine, which disappeared in the 17th century owing to the Baroque renovations or, at the latest, during the 1771 fire, and which in the early 16th century still led Perin del Vaga to emulate it (the episode is mentioned by Vasari in Perino's biography). Hardly anything is known of this work and its patrons: according to the primacy granted to Saint Peter by the Carmelite Order, Masolino, as he was older, was offered the possibility to choose first. Yet, we do not know if it was effectively a sort of general rehearsal for the more engaging Brancacci cycle, or if the lost *Saint Paul* by Masaccio was executed after the *Saint Peter* to prove whether it was stylistically compatible with Masolino, who had started the works in the chapel. This uncertainty at least initially, might have occasioned some apprehension.

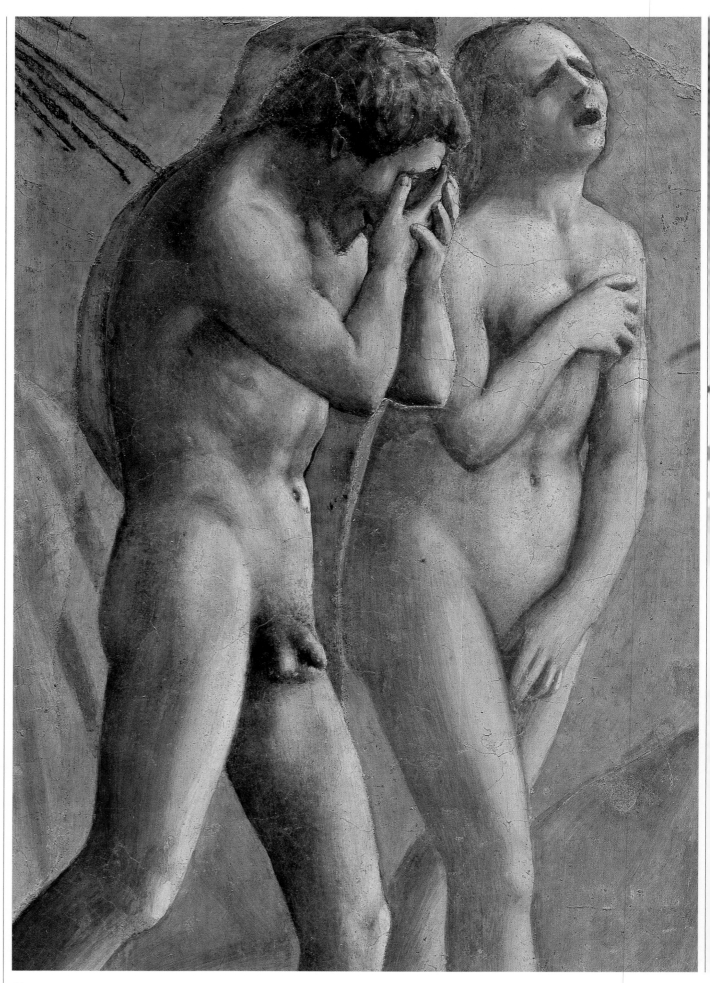

14

Tha Brancacci Chapel, a School for the World

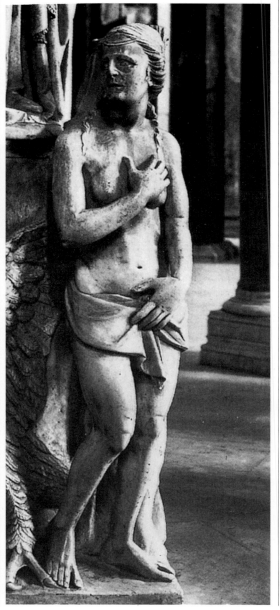

THE DECORATION OF the Brancacci Chapel, in the right-hand transept of the Church of the Carmine, is the most intricate aspect and the key-episode of the relation between Masaccio and Masolino. Surprisingly, what was defined by Ingres "the cradle of fine painting" does not enjoy solid documentary evidence. The absolute lack of documents in the archives about the artists and patrons is disconcerting at the least; nonetheless, it is one of the most important decorative undertakings since the times of Spinello and Starnina, by far more significant than the slightly earlier decoration of the Bartolini Salimbeni Chapel in the Florentine Church of Santa Trinita by Lorenzo Monaco which perhaps, at least initially, represented a reference point.

Around the middle of the 18th century, the upper part was demolished during the renovation of the vault (frescoed by Meucci and Sacconi in 1746-1748) which showed the *Evangelists* in the sections of the vault and perhaps the heads of the Saints on the underside of the entrance arch as Masolino later did in the Roman Church of San Clemente. It remains uncertain whether Masolino was the only one who started this engaging and iconographically innovative cycle, at least it was such for the Florentine context. Even the sinopias found during the recent restoration of the two semi-lunettes on the end wall, divided by the Gothic two-light window, do not fully explain the problem; moreover, they belong to a later stage compared to the lost dome vault. It is rather unclear whether one of them, with a scene recognized as the *Repentance* or *Lamentation of Saint Peter*, can be attributed to Masaccio, whilst the other – with the *Pasce oves meas* – is almost completely faded and it is not easy to judge, even if its similarity to the Empoli sinopias by Masolino cannot be denied. In the lower tier the composition programme appears so well-balanced, that it suggests a rigorous, single and planned project: notwithstanding their stylistic differences, the two painters worked in harmony, and with almost a deliberate search for correspondences and correlations. All this cannot be the result of Masaccio's accidental and sudden intervention owing to Masolino's difficulties or subsequent engagements; on the con-

On page 14:
Expulsion from Paradise (1424-1425), detail; Florence, Church of the Carmine, Brancacci Chapel.

On page 15:
Giovanni Pisano, pulpit (1302-1311), detail with the statue of *Prudence*, Pisa, Duomo.

The realism characterizing the tragic figures of our progenitors is linked to the art of antiquity, whose revival represented an absolute novelty compared to the pictorial style of the time. The same applied to the modelling used by the artist to depict the plastic figures of Adam and Eve, showing his interest for volumes, also confirmed by his attraction for sculpture and his friendship with some contemporary sculptors: actually, Eve appears as a sort of pictorial image of the Graeco-Roman statue of the "Venus Pudica", filtered through the representation given by Giovanni Pisano on the pulpit in Pisa Cathedral. Michelangelo (one of his drawings of *Adam and Eve* is at the Louvre) and Raphael both drew their inspiration from Masaccio's painting for the execution of their frescoes on the same subject for the vault of the Sistine Chapel and the Vatican Loggias.

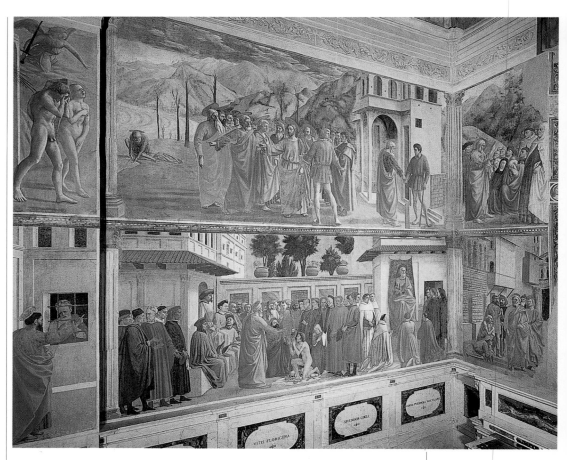

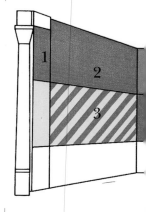

Here above: outline of the frescoes covering the walls of the Brancacci Chapel in the Church of the Carmine, Florence.

The scenes painted by Masaccio are red and numbered; Masolino's are green; later scenes, executed by Filippino Lippi, are yellow. The numbered, red and yellow striped part points

trary, it is the coherent result of a single and monitored project. The stories of Saint Peter are linked to the praising of the antiquity (for the Middle-Eastern origins of hermits) and the pro-Papal orthodoxy professed by the Carmelite Order – the polemic controversies of the Council were not completely settled, and the recovered union of the Western Church had just happened. Indeed, the inspirator of the programme was probably a Carmelite, but he has never been identified up to now.

It is also unknown how the choice of themes and the selection of episodes – framed by the two episodes of the Old Testament, the *Expulsion* and the *Temptation of Adam and Eve* placed at the two ends of the tier (it is striking how the succession of the episodes is inversed, the usual reading being from left to right) – had anything to do with the interests of the Brancacci family, though it has attracted the critics' attention. Scholars agree, with few exceptions, that merchant Felice Brancacci was the presumed patron of the costly cycle, a man engaged in politics and the undiscussed leader of his family, at least until he was exiled after colliding with the Medici's interests. The expansionist commercial politics, the search for new markets seem to be hinted at by the recurring scenes – in the now lost top tier, known from the sources or from sporadic late copies – with the predominant liquid element: the *Calling of Saints Peter and Andrew,* and *Christ Walking on the Water.* The richness given by the sea – the acquisition of Pisa, decisive for the Florentine Republic (which originated Felice's political success) and Leghorn, which he warmly, and not disinterestingly, advocated –, the confidence in the prosperity coming from trade, are certainly themes compatible with the merchant's business, but they have nothing to do with the Carmelites' interests. It has not been ascertained that the patrons exercised such a strict control as

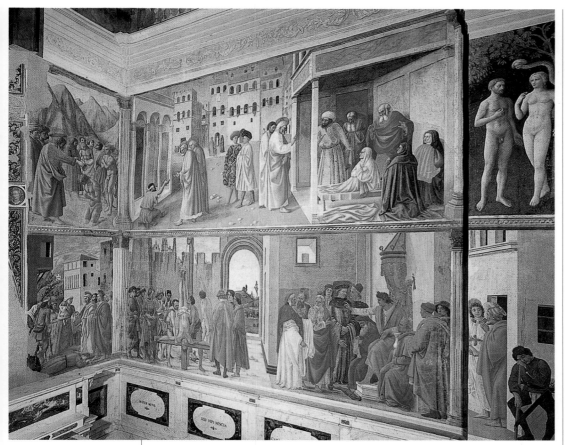

**Opposite
and at the side:**
the left and right
walls of the Brancacci
Chapel
in the Church
of the Carmine,
Florence.

out that the fresco
was painted
by two different
hands (Masaccio
and, later,
Filippino Lippi).
1. *Expulsion
from Paradise*
2. *Tribute Money*
3. *Raising of the Son
of Theophilus
and Saint Peter
Enthroned*
4. *Saint Peter
Healing the Sick
with his Shadow*
5. *Saint Peter
Baptizing Neophytes*
6. *Distribution
of Alms and Death
of Ananias*

to impose decisive conditions on iconography: in this case it cannot be easily stated. The delicate relations between the Church and the State, because of the question of the tithe, which the Republic had to impose periodically on the Florentine clergy during the difficult years of the fights against the Visconti – it is the core of the phase which led to the institution of the *catasto* in 1427, after considerable protests on the part of the Florentine oligarchs, Brancacci included – are in a way evoked, some say, in the *Tribute Money,* the climax episode of the tier in question, together with the *pendant* by Masolino, the *Raising of Tabitha.* However, Brancacci's role, if Felice can actually be considered the patron, (but it still has to be proven), does not seem enough to attract for his cultural expectations and perspectives unmerited responsabilities, such as a choice of programme tailored on the needs of the Papacy or the reasserted secular *fidelitas* of the Carmelites.

When the two painters divided up their work, it should be pointed out that they assumed the parts with the themes they preferred (or was it the patron's choice?). Masaccio in his *Tribute Money* discomposed the narrative sequence and the hierarchy of the episodes: the miraculous event – Peter finding a coin in a fish, after following Jesus' indication – is confined at the far end, the *historia* is all summarized in the central section, Jesus entrusting Peter is the crucial point of the whole wall. The painter's confident criticism allowed him to replace hagiography with a clear and firm singling out of the heart of the matter, of the historical roots of Peter's authority: his pastoral mission which descends directly from Christ and which can also comply with civil duties, not in contrast with the State's laws («render unto Caesar that which is Caesar's»). There is no other work of this period, even less so any remarkably good painting by Masolino on the opposite wall,

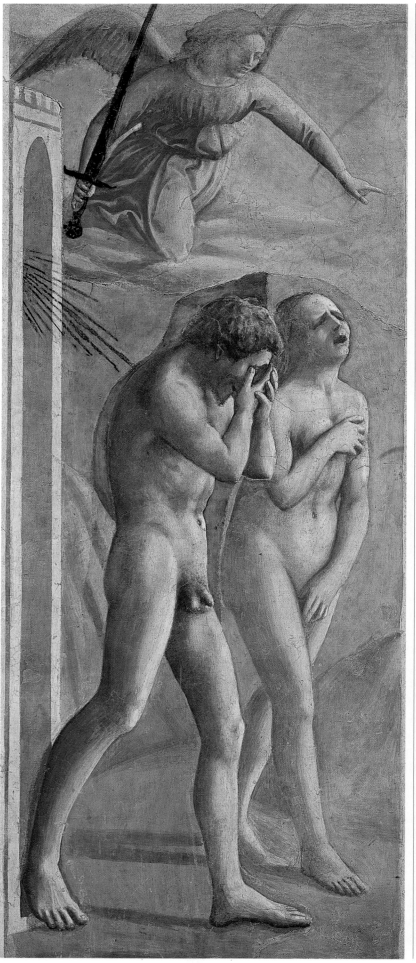

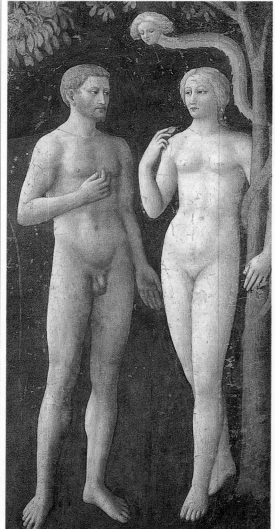

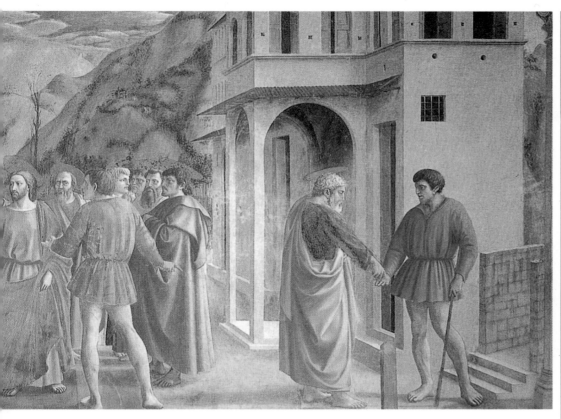

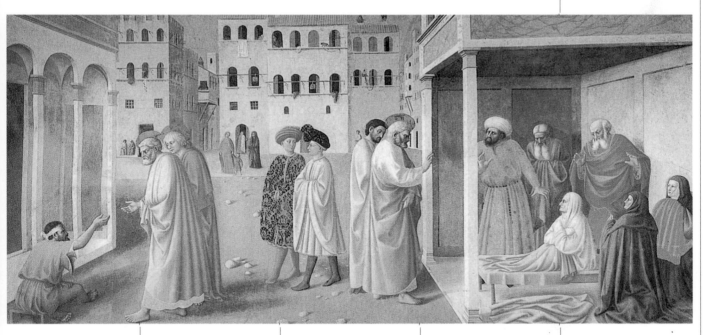

The paintings here reproduced belong to what originally was the central tier of the cycle (the upper tier went lost during the 18th-century renovation of the vault); this tier presents the most significant scenes of the whole fresco and the composition is highly homogeneous and consistent. Though the Brancacci Chapel frescoes are not sufficiently documented, it is this very same consistency characterising the project that exclude, though each contribution has a peculiarity of its own, a "forced" collaboration between Masolino and Masaccio, imposed by an accidental situation.

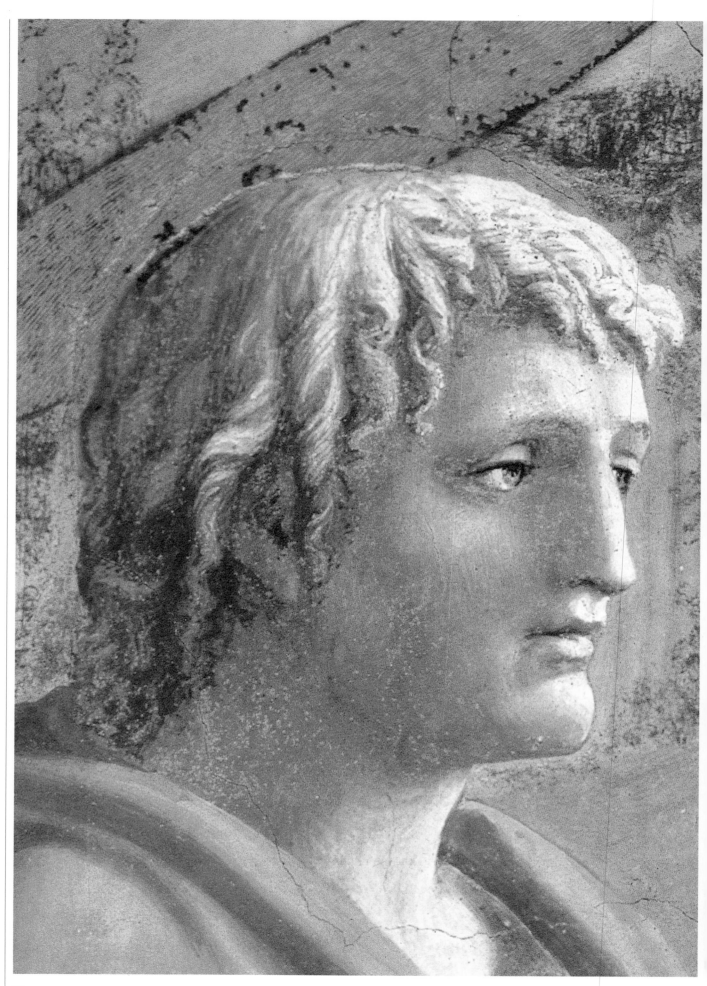

20

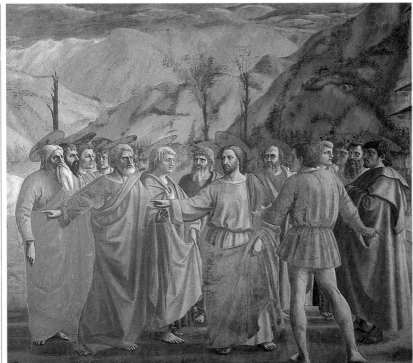

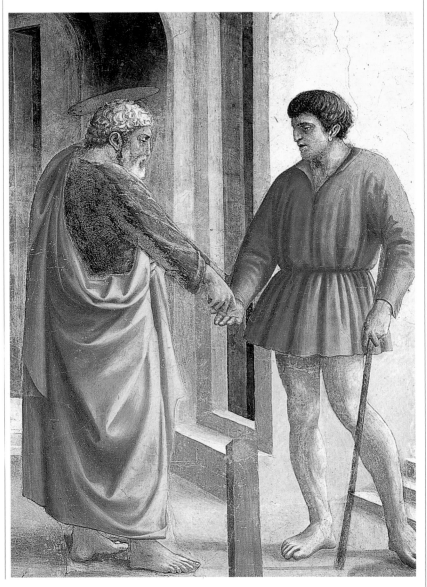

Opposite, here above on the right, and below: *Tribute Money* (1425), details; Florence, Church of the Carmine, Brancacci Chapel.

Top: Nanni di Banco, *Four Crowned Saints* (after 1413); Florence, Orsanmichele.

A revival of classical elements and attention to plastic arts can also be found in the pattern of the *Tribute Money*. In this fresco the group of apostles, disposed in circle around Christ, is reminiscent of the four saints sculpted by Nanni di Banco in a niche of the Florentine Church of Orsanmichele. Such a composition scheme already existed in ancient times, frequently used to represent Socrates and his disciples. Adopted in the early Christian period to represent Christ and the Apostles, during the early Renaissance the motif of the circular arrangement found its place in the symbolic interpretation of the circle, a figure which epitomizes perfection.

which can show such a precise space measurement given, as Donatello did, to the arrangement of the figures, real "ancient" statues painted with such freshness. The painters perceived this, and at the end of the 16th century, the essayist Lomazzo said that Masaccio «painted the light and shade of the figures without contours» (1584), while to Vasari the chapel was a real «school for the world» where generations of artists studied. Undoubtedly, part of the composition, with the Apostles arranged in a semi-circle around Christ, was inspired by the group of the *Four Crowned Saints*, executed by Nanni di Banco for the Church of Orsanmichele in Florence. Nanni was a very promising artist; he had a workshop in Borgo Allegri, like Ghiberti, and held public offices; he died prematurely like Masaccio. Moreover, the very same Neo-Roman looks of some Apostles seem to be a homage to Nanni and to his sources on antiquities. A significant comparison can be made with the four Egyptian martyrs in the niche of the masons' guild headquarters. It seems that Donatello gave suggestions about the semi-circular disposition of the statues in exchange for a dinner – yet, this anecdote told by Vasari, as well as his many others, is doubtful. Masaccio often met with his friends sculptors – his acquaintance with Donatello is documented for nearly all of 1426, but had probably started much earlier – and this is proven by the *Expulsion* where Adam looks like Hercules or Prometheus and Eve is reminiscent of the *Venus pudica* taken from the ancient statue documented in Florence at the time, or from Giovanni Pisano's more moving interpretation in the pulpit of Pisa Cathedral. The angel's gesture is meaningful, chasing the progenitors from Eden

**Here below,
from the left,
and opposite, right:**
*Saint Peter Baptizing
Neophytes*
(1424-1425),
details
and full painting;
Florence,
Church
of the Carmine,
Brancacci Chapel.

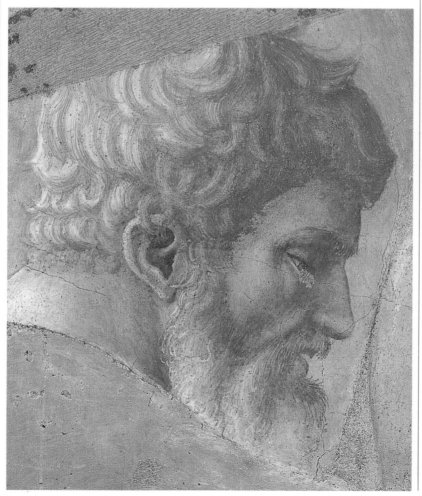

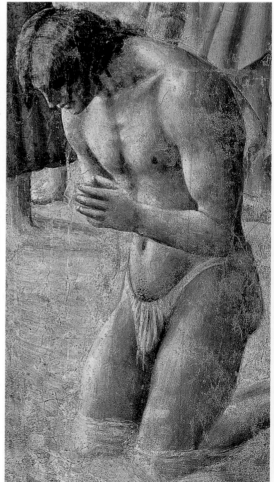

22

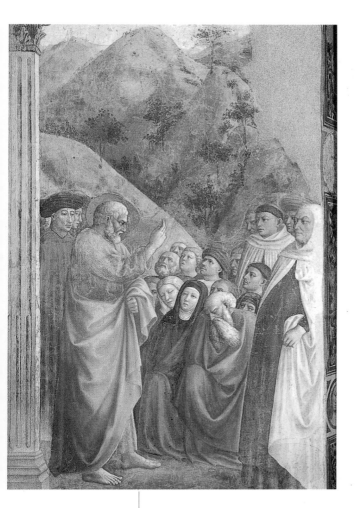

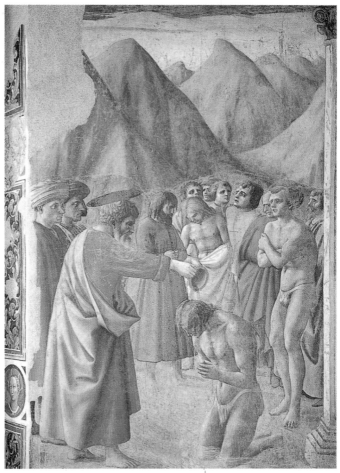

Here above:
Masolino da Panicale,
Saint Peter Preaching
(1424-1425);
Florence,
Church
of the Carmine,
Brancacci Chapel.

**The *Acts
of the Apostles*, a work
which continues
the narration
of the Gospels
illustrating especially
the vicissitudes
of Peter and Paul,
and the phases
of their preaching,
are the source
of *Saint Peter
Preaching*
and *Saint Peter
Baptizing Neophytes*
(in particular, chapter
2,41: «they that gladly
received his [Peter's]
word were baptized:
and the same day
there were added
unto them about
three thousand
souls»). Describing
Masaccio's fresco,
Vasari wrote:**

with a movement already foretelling Divine Mercy (this is how it will be interpreted by Raphael in the Vatican Loggias, where an angel puts his hand on Adam's shoulder sympathetically, accompanying him gently). Vasari and also earlier sources praised especially the figures of the *Baptism*, particularly «a naked man trembling» who is waiting for his turn shivering. They are in the central tier on the end wall of the chapel: on the other side of the window Masolino painted *Saint Peter Preaching*. These two episodes of the *Acts of the Apostles* – which is not the only inspiring source of the cycle – are strictly connected and represent two important moments of salvation by means of the Church and its Shepherd. The uncertain attributions of so many critics, who theorize interventions of each in the fresco of the other, can be explained by the remarkable search for unity of this wall, where the interventions are balanced, also in the choice of colours, in the aim of obtaining a unifying vision with a "linking" landscape, the same line of horizon and a single perspective arrangement. This is a remarkable device, confirming the rigour of the project aiming at the consistency of the whole, with the end wall decorations disposed on both sides of the long gap created by the two-light window.

Although oceans of ink have been spilt on the uncertain chronology of the work and its several phases, an evident gap can be noted on the lower tier of the Brancacci cycle. Something inverted the initial plans, and the balanced continuity with the upper tier is lost. Masolino is absent here, having left Masaccio to work alone, after setting off for Hungary in September 1425, attracted by much more profitable commissions, in theory at least. But it was a different Masaccio who painted the last stories of

**«In the scene showing
Saint Peter baptizing
there is a figure
of a naked man,
who is trembling
and shivering
with cold as he stands
with the others who
are being baptized.
This is very highly
regarded, being
executed in very fine
relief and in a very
charming style;
it has always been
praised and admired
by artists. Because
of Masaccio's work,
this Chapel has
been visited
from that time
to this by an endless
stream of students
and masters. There
are still some heads
to be seen there
which are so beautiful
and lifelike that one
can say outright
that no other painter
of that time
approached
the modern style
of painting as closely
as he did».**

Saint Peter leaving them unfinished for unknown reasons. Brancacci, the patron, probably had not paid his due (even if he had unscrupolously subtracted a considerable sum of money from the treasury; was it an early episode of *Tangentopoli* in relation with his paying the painters?) and perhaps was not interested any longer in a work so ouvertly pro-Papacy; Masolino back in Italy had invited Tommaso to join him in Rome and the Carmelites had obediently given up the work to favour the important commissions of the Curia; or perhaps it was some other reason. The cycle, as everybody knows, was finished much later by Filippino Lippi. It was in the middle of the age of Lorenzo the Magnificent in the early 1480s, but a strange destiny again seemed to await the Brancacci Chapel: we do not know the exact date of the intervention, the circumstances, the patron, the modifications of the pre-existing works (whether and to what extent the painter presented, or was imposed to present, changes to the programme). And it was not the fault of the family's political misfortunes: the tensions were loosened, the Medici's power had become solid, even the Brancaccis had been rehabilitated.

The scenes, more precisely the sections started by Masaccio on the lower tier, reveal a narrative taste more incline to naturalism; if compared to the severe atmosphere of the *Baptism* and especially of the *Tribute Money*, the artist seem to have precociously started studying the Flemish descriptivism, such as Van Eyck's, which later interested Filippo Lippi and Domenico Veneziano –

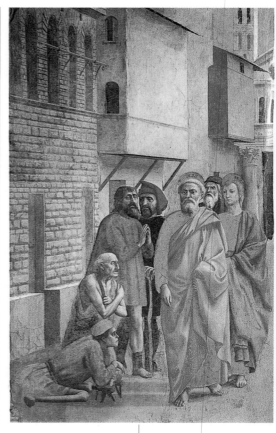

Here above and left:
Saint Peter Healing with his Shadow (1426-1427), whole and detail; Florence, Church of the Carmine, Brancacci Chapel.

The two episodes reproduced on these pages are on the lower tier of the wall. Masaccio did not complete the painting of this section, which was finished much later by Filippino Lippi. Masolino did not intervene on the lower tier, because he went to Hungary at the end of 1425, where he had obtained some commissions.

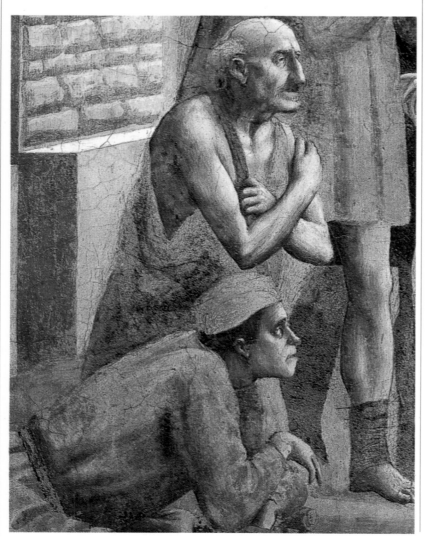

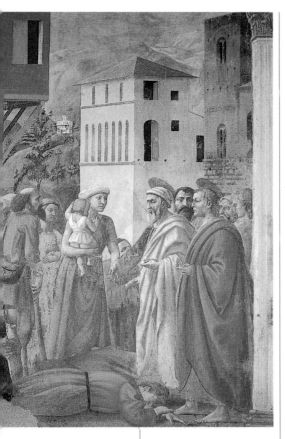

as well as its richness in details and the arrangement of the architectural setting. A typical example is the luxurious palace of Theophilus, the governor of Antioch, whose son is raised by Peter. The recent restoration has definitely established that the magnificent background is by Masaccio, who found a generic inspiration in Brunelleschi, for example with his preference for white marble – but the motif of the wall with polychrome marble insets, with pots and trees visible on the background, is taken from Taddeo Gaddi and is a confirmation of Masaccio's knowledge of 14th-century sources. The realizations were so *avant-garde* that many suggested an intervention by Filippino. It is not clear what propped such a significant change of style in Masaccio, but it might be due to an important commission on which we have little information. The friars (?) asked Masaccio, it is not known exactly when – in my opinion, probably between the second and third tier of the Brancacci Chapel – to celebrate the consacration of the church, which took place in 1422 at the presence of Florence artists and ruling class; Masaccio was very likely an eye witness of the event. This was the origin of the *Sagra*, which was unfortunately lost during the renovation of the first cloister of the Carmine (from 1597 to 1614), having been painted in a lunette above the door leading to the church (the exact collocation is not known either, because of later modifications). Mentioned in the sources as one of the painter's masterpieces – first of all by Antonio Manetti, who gathered the influential statement of Scheggia in 1472-1473 –, today

Here above and right:
Saint Peter and Saint John Distributing Alms and Death of Ananias (1426-1427), whole and detail; Florence, Church of the Carmine, Brancacci Chapel.

This scene is taken from the *Acts of the Apostles*, 4,32; 5,1-11, a well-known passage on the sharing of goods in the first Christian communities. The Ananias' episode is part of it: he sells a field and then intently declares to the community only part of the money received; on this account he is struck by God's punishment and falls dead at Peter's feet. Like the *Tribute Money*, it has been suggested that the *Death of Ananias* fresco hints at the new tax-system, established in Florence in 1427.

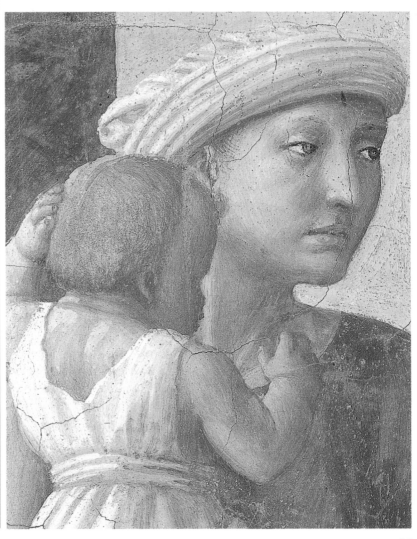

Right and opposite, below:
Masaccio
and Filippino Lippi,
*Raising of the Son
of Theophilus
and Saint Peter
Enthroned*
(1427-1428/
1484-1485),
detail
and whole;
Florence,
Church
of the Carmine,
Brancacci Chapel.

the work can only be partly reconstructed, starting both from a detailed description by Vasari, who tried to identify some of the characters, and from a group of drawings by various authors – all of later and different periods – as well as from comparisons with later works of a similar subject (but not in the so-called *Consacration of Sant'Egidio* by Bicci di Lorenzo, which would seem completely autonomous). This work was extremely successful with the Florentines of the time: the ruling class loved to see their likenesses among the onlookers, among whom Brunelleschi «wearing clogs» (Vasari). It was the first time that an event of contemporary public life ascended to the rank of history, in close relationship with the most illustrious tradition. The chronological uncertainties do not allow us to establish if this work was prior to the beginning of the cycle of the Green Cloister's large lunettes in Santa Maria Novella, which are also uncertain, but the choice of the monochrome has a precise and intentional meaning: it consented to emulate the effects of the ancient celebratory relief and to be connected directly with the classical tradition. Alberti in his *De pictura* mentions Aglaophon who used only one colour, and Polygnotus and Thimantes who restricted their palettes to four colours, perhaps just like Masaccio with his *Sagra*.

A reflection should be made on the Florentines' self-aware-

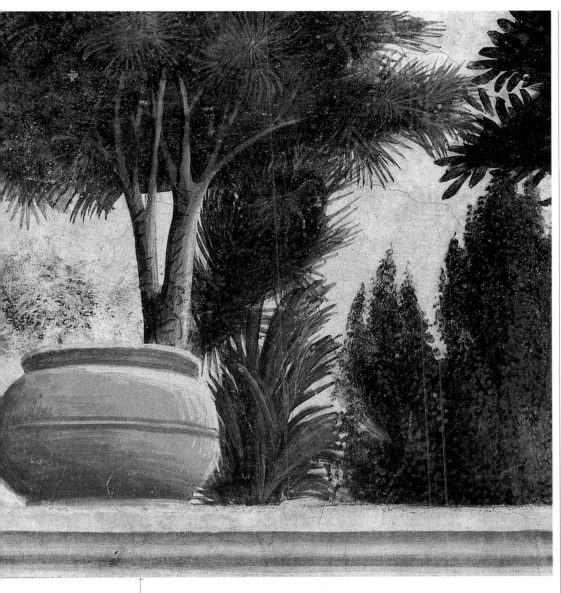

In the lower tier of the Brancacci Chapel, Masaccio adopted a rather different style from that used for the scenes of the upper tier. There is a tendency to more marked realism and descriptivism, with a style similar to that used in Flemish painting, which linger on details and embellish the backgrounds with architectural settings rendered in an extraordinarily accurate way. Among the architectural backgrounds of the lower tier, that painted by Masaccio in the *Raising of the Son of Teophylus*, left unfinished and then completed by Filippino Lippi in the 1480s, is magnificent: there is a wall elegantly decorated with veined marble insets; on top of it are round earthenware pots, and green tree-tops can be seen over the wall.

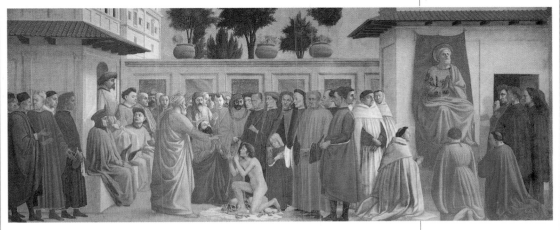

ness and on their strong feeling of a crucial historical role during the difficult Republican period: the *Sagra* transformed a crowd of plump middle-class people and prelates, full of curiosity, in a group of statues of Catos, Lelis and Scipios. A taste for portraits, even of multiple portraits, rapidly spread in the city thanks to the good fortunes of the work as some panels prove – all of which are later works, except the Boston *Young Man* which, alone, can still be considered autograph, although a degree of uncertainty remains.

The Pisa Altarpiece

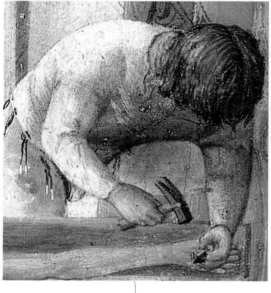

Here above and opposite:
Crucifixion of Saint Peter and Beheading of Saint John the Baptist, panel of the predella belonging to the dismantled and partially lost *Pisa Altarpiece* (1426), details; Berlin, Staatliche Museen.

The polyptych in Santa Maria del Carmine in Pisa has been dismantled and some of its compartments are lost, as those featuring the saints at the sides of the main painting. The remaining panels are in museums in Europe and overseas. Berlin has the greatest number of works: the three parts of the predella (bought at different times and still disjoined) and some pictures of saints.

URING HIS discontinued activity in the Brancacci Chapel Masaccio was commissioned a number of works, such as the one for the consacration of the Church of Carmine.

However, once Masolino had left, Masaccio's enthusiasm died down. Perhaps he awaited his collegue's return, abiding by any previous agreement and by the terms of delivery (though it was agreed from start that Masolino would be away for three years). There is evidence that in 1426 Masaccio went to Pisa several times and in the Carmelite church executed an impressive altarpiece, that was later dismantled and partially dispersed. Giorgio Vasari managed to see the work and gave a detailed description of it in the second edition of his *Lives of the Artists,* which is not always accurate in attributing paintings to Masaccio. The fresco was commissioned by Giuliano di Colino degli Scarsi, a notary in Pisa, and was to decorate the chapel built by the mason Pippo di Gante, better known as the father of the sculptor Isaia da Pisa. Thanks to the notary's meticulous recordings the work is rather well documented: it was an important commission, hence Masaccio had to adapt the main project to a specific wooden framework in line with standard late 14th-century polyptychs of medium size.

The sum of 80 florins was the agreed current price and was paid in successive stages as if the patron wished to survey the work in progress. Payment was sometimes made in the presence of his friend «Donatello the stone-drummer» (which is a rather inelegant name for the father of modern sculpture) and when Masaccio was away the money was paid to «his apprentice Andrea di Iusto» (there was another assistant whose name is omitted by the notary) or his brother Scheggia (and also to Donato who owned a workshop in Pisa used by Michelozzo and Masaccio as their base when the two sculptors worked at the sepulchral monument of Cardinal Rinaldo or Rainaldo Brancacci, to be shipped to Naples). As the date of the full payment approached the notary insisted on guarantees that the altarpiece would be finished without any delay. Perhaps he was made sus-

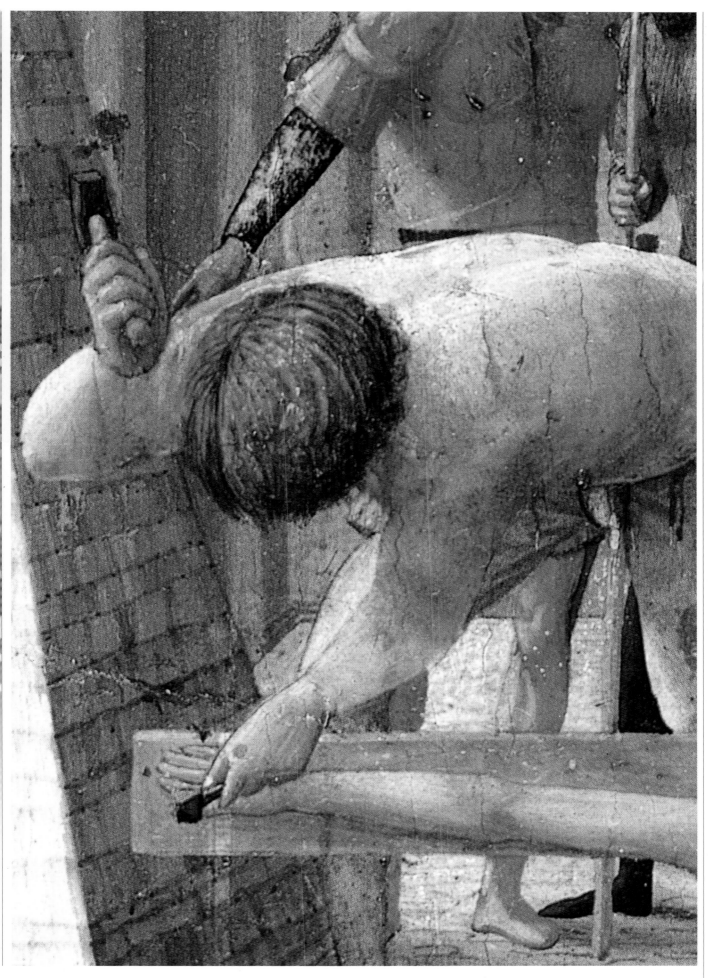

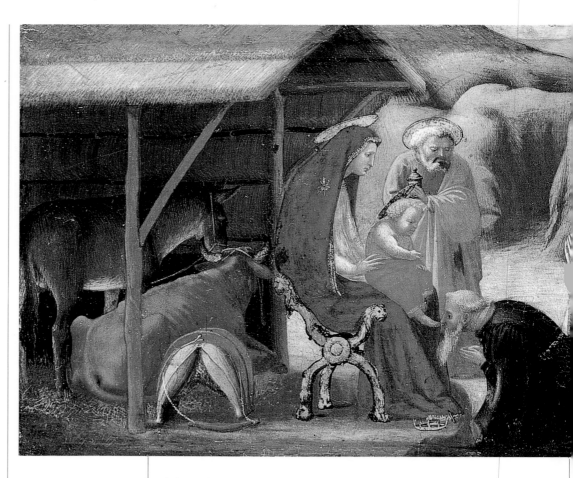

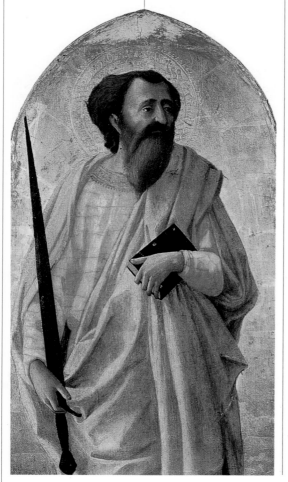

picious by Masaccio's recurrent trips or he was aware that the painter had received a new commission and feared the work would remain unfinished. Indeed, in October he writes: «He has promised that he will not undertake any other work before he finishes this one, and has put this in writing». He must have been on the alert if he asked Masaccio to put this promise down in black and white.

The original altarpiece included the chapel commissioned by Ser Giuliano, which was dismantled and sold at an uncertain date despite Vasari's words of praise in the 1568 edition of his *Lives.* What is left in Pisa is a three-quarter portrait of *Saint Paul,* belonging to the upper part of the altarpiece, and a *Saint Andrew* bought by the John Paul Getty Museum in Malibu twenty years ago. The four lateral saints grouped in pairs as in the *San Giovenale Triptych* according to an improved arrangement (their life-stories match on the predellas too) were dispersed. However, the predella saved in Berlin-Dahlem enables the reconstruction of the missing pieces: St John the Baptist, Saint Peter, Saint Julian and Saint Nicholas (the notary was called after the latter two saints: Giuliano, Italian for Julian, di Colino, short for Nicolino; St John is the patron saint of Florence which in 1406 submitted the town of Pisa; the tribute to St Peter confirms the important role the Carmelite order played in Rome). The centre of the predella displayed the *Adoration of the Magi,* whilst on the central panel of the altarpiece there was the *Virgin and Child Enthroned* with four angels, now in the National Gallery in London, which was surmounted by a cymatium with the *Crucifixion* saved in Capodimonte Museum, Naples.

Two smaller full portraits of saints have reached us too, being probably part of the lateral pilasters. Two depict the Fa-

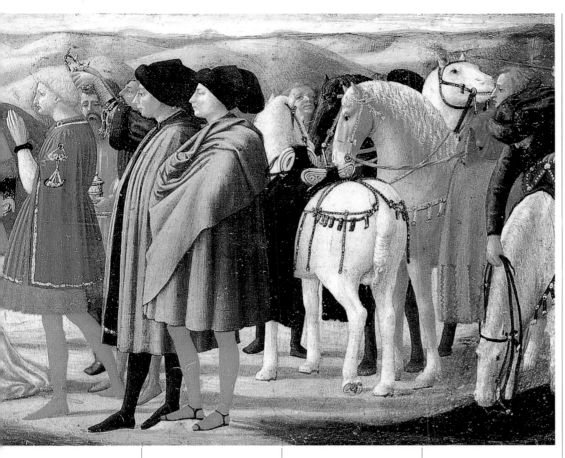

Here below:
Saint Andrew,
upper storey panel
belonging
to the dismantled
and partially lost
Pisa Altarpiece
(1426);
Malibu, CA,
John Paul Getty
Museum.

Here below:
reconstruction
of the dismantled
and partially lost
Pisa Altarpiece
(1426).

1. *Saint Paul*;
Pisa,
Museo Nazionale.
2. *Crucifixion*;
Naples, Museo
di Capodimonte.
3. *Saint Andrew*;
Malibu, CA, John
Paul Getty Museum.
4. *Virgin and Child
Enthroned*;

London,
National Gallery.
5. *Saint Augustine*;
6. *Saint Jerome*;
7. *Carmelite Saint*;
8. *Carmelite Saint*;
9. *Crucifixion
of Saint Peter
and Beheading of Saint
John the Baptist*;
10. *Adoration
of the Magi*;
11. *Legend of Saint
Julian and Saint
Nicholas and the Poor
Man's Daughters*;
Berlin,
Staatliche Museen.

The compartments
without numbers
were dispersed.
At the side
of the *Virgin
and Child Enthroned*
there were probably
two couples of saints:
Saint Peter and Saint
John the Baptist
(on the left);
Saint Julian
and Saint Nicholas
(on the right),
the main figures in
the panels depicting
the central episodes
in their earthly lives.

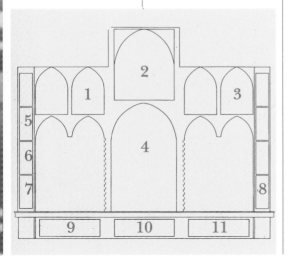

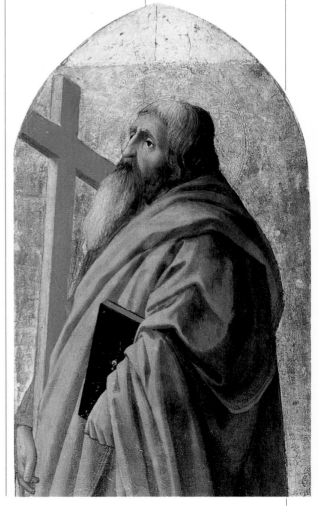

Right and below:
Legend of Saint Julian and Saint Nicholas and the Poor Man's Daughters, panel of the predella belonging to the dismantled and partially lost *Pisa Altarpiece* (1426), detail and full painting; Berlin, Staatliche Museen.

Opposite, top and centre:
Crucifixion of Saint Peter and Beheading of Saint John the Baptist, panel of the predella belonging to the dismantled and partially lost *Pisa Altarpiece* (1426), detail and full painting; Berlin, Staatliche Museen.

The legend of Saint Julian the "Ospitaliere", also known as "the murderer saint", is contained in the *Golden Legend* by Jacopo da Varagine, a Latin work of the 13th century which was translated in Vulgar Latin and became popular in the 14th century. According to the story, Julian killed his parents unable to stop a fatal prophecy. He then expiated his murder through a life of penance which eventually gained him God's forgiveness. On the left of the panel shown at the side herein, Masaccio painted the crucial episode of the saint's life, showing him in the act of striking with his sword the lethal blow that would kill his sleeping parents.

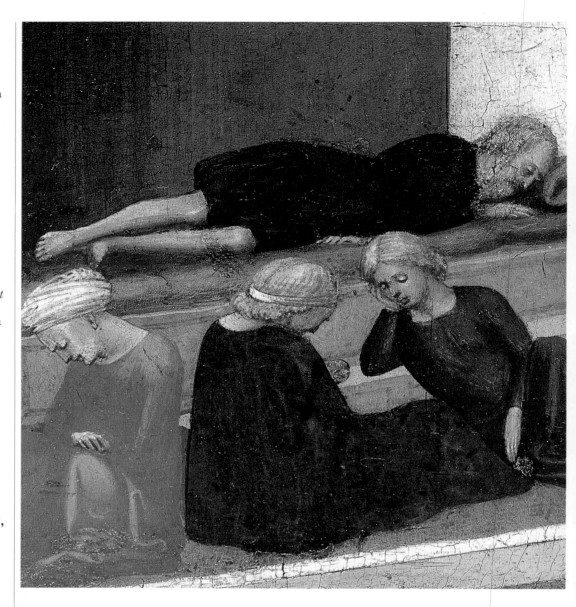

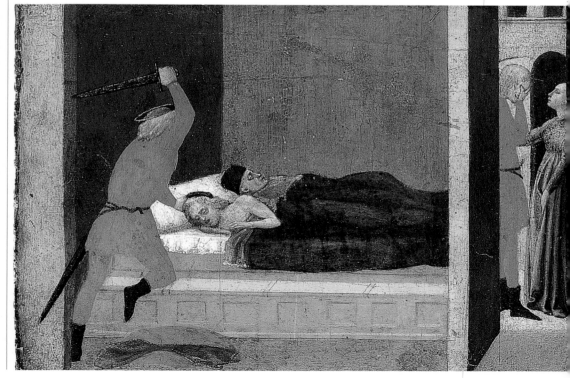

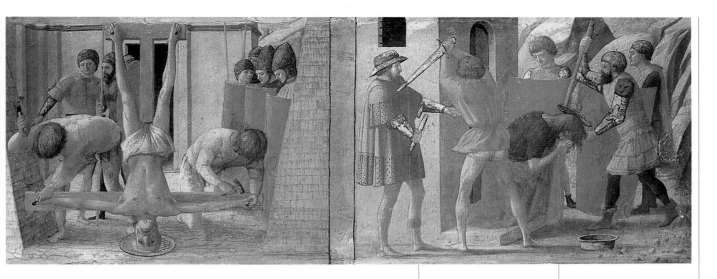

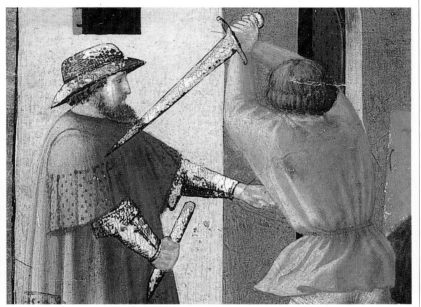

Here below:
Gentile da Fabriano,
Quaratesi Altarpiece
(1425),
predella
with the scene
of *Saint Nicholas
and the Poor Man's
Daughters*;
Roma,
Pinacoteca Vaticana.

On the righ
of Saint Julian's
murderous scene,
Masaccio paints
a revealing episode
in the life of another
saint, Nicholas
of Bari. Having
heard that a poor
man intended
prostituting
his three daughters,
one night
Saint Nicholas went
into their house
and left the girls
with three golden
balls so that they
could marry
into wealthy families.
The painting was
certainly inspired, yet
not rigidly influen-
ced, by Gentile
da Fabriano's
painting on the same
episode decorating
the predellas
of the polyptychs
executed
for the Quaratesi
and Strozzi families.

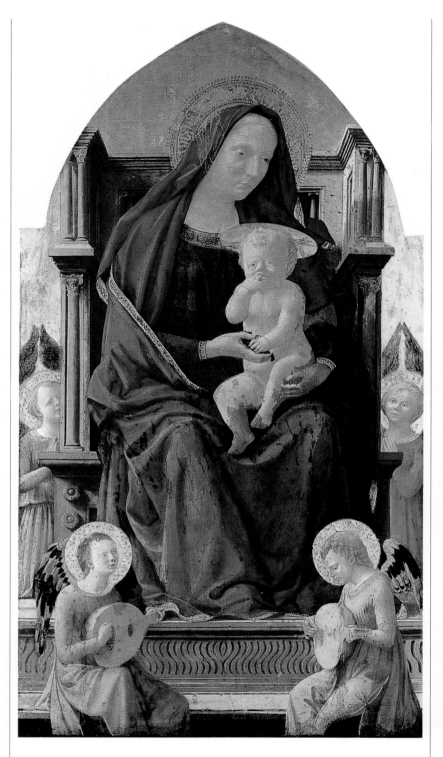

thers of the Church (perhaps in a collection of four figures) and two are Carmelite saints (possibly Alberto Avogadro and Angelo Licata). However, any attempt at reconstruction can only offer an incomplete picture of what the altarpiece must have been like originally and of the number of missing pieces.

The remarkable shape of the Virgin's throne is rather unusual given the ogival shape of the central panel. It evokes the large size in fashion during the 14th century, featured in works by the Maestro di Santa Cecila or in the *Stefaneschi Polyptych* by Giotto and his assistants. Masaccio improved its structure by adding elements in the style of Brunelleschi, rendering his first clear homage to the great artist: the coupled Chorinthian columns from the "polygonal galleries" of the Florentine Cathe-

dral; the archaistic strigils from the frieze of the Spedale degli Innocenti in Florence, soon to be dismissed. Given the late Gothic framework, such innovations seem aimed at *épater les bourgeois*, stunning the onlooker. The picture of angels playing music offers a strict perspective of their lutes, though examples of daring foreshortening of the same type may be found in 14th-century paintings in Tuscany. Moreover, the play of light and the

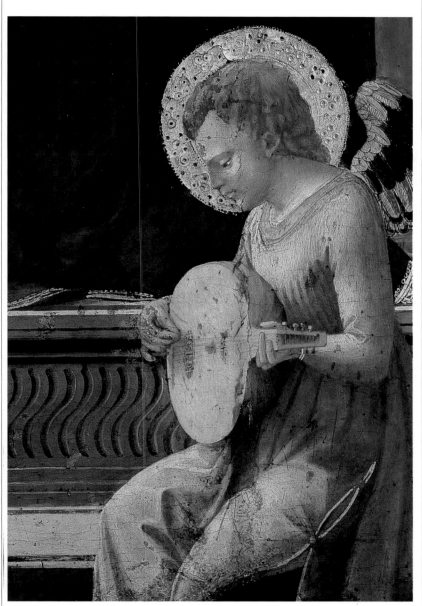

chiaroscuro effects, the manumental figures and their spatial display are genuine innovations.

There is no way of knowing today how the Pisan artistic community reacted to Masaccio's inventiveness; it is not unlikely that the painter received other commissions from the notary as there is evidence of Masolino's activity in the town even before Vasari's *Lives*. Possibly the two worked jointly rather than one simply aiding the other as suggested by the small altar saved in the German museum of Altenburg and probably executed in Pisa. The presence of differences in style and spatial display makes its attribution to Masaccio alone unlikely.

The stories on the lateral predellas belonging to the *Pisa Altarpiece* show analogies with the frescoes in the Brancacci Chapel,

Here above:
Carmelite Saint, panel of the right pilaster belonging to the dismantled and partially lost *Pisa Altapiece* (1426); Berlin, Staatliche Museen.

of which they are some kind of less formal and more intelligible counterparts. A number of inconsistencies, rare in Masaccio's works and thus all the more striking, are probably due to the need to complete or to the contribution of others. The predellas Gentile da Fabriano executed for the Strozzi and Quaratesi families were the models with which he had to compete; yet, Masaccio was unmoved either by the wealth of details or the highly complex structure of such paintings, preferring a rather simpler and unadorned style to portray the saints' lives. Both painters depicted the story of Saint Nicholas, who helped three poverty-stricken girls by giving them gold for their dowries, thus their works may be conveniently compared. More than once Masaccio seems to have represented the murderous episode in Saint Julian's life in which he killed his parents only to spend the rest of his life filled with remorse. Indeed, the badly damaged predella saved in the Horne museum in Florence has been attributed to him and, though very little is known on this piece, it is unlikely that it belonged to the Pisa polyptych as its size does not match that of the altarpiece (some have suggested that it may have been an early version subsequently replaced by the artist).

This painting on the story of Saint Julian was doubtlessly put on public view because it was vandalized, as often happened with works displaying the devil. Moreover, it inspired other Florentine painters, notably with regards to the figure of a foreshortened hound. The latter feature draws inspiration from ancient historians such as Pliny, who according to the 16th-century Anonimo Magliabechiano reported that Pausia di Sicione had foreshortened an ox and Nicia Ateniese «became popular painting animals on four legs and especially dogs». What attracted Masaccio was not so much the killing itself, as the admission of guilt and the deafening scream with which the saint started his

Below and opposite:
Crucifixion,
cymatium belonging
to the dismantled
and partially lost
Pisa Altarpiece
(1426);
detail
and full painting;
Naples,
Museo
di Capodimonte.

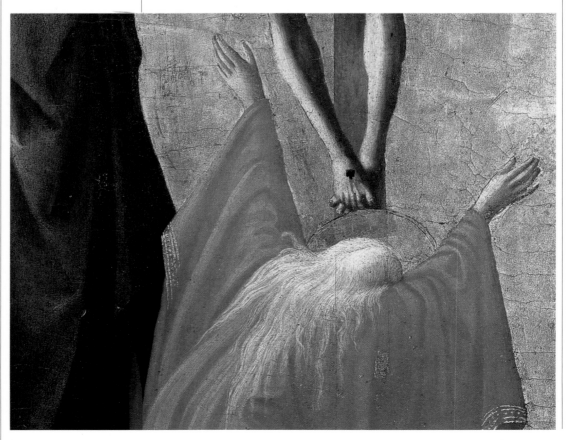

The panel which at one time used to surmount the *Pisa Altarpiece* is one of the most famous works by Masaccio. The picture of Maddalena at Christ's feet is a touching picture of grief. She is painted from behind, her facial expression concealed, thus her despair is expressed all the more vigorously as her arms stretch out towards the cross in a silent lament. The deep colour of her cloak, as intense as the scene itself, defines her figure through its folds and the striking contrast between its bright red material and the dazzling golden hair. Christ is painted with his head deeply set between his shoulders, revealing an early attempt at foreshortening from below. The cross, renovated by a restoration between 1953 and 1958 which eliminated the all too common inscription INRI, is surmounted by the Tree of Life.

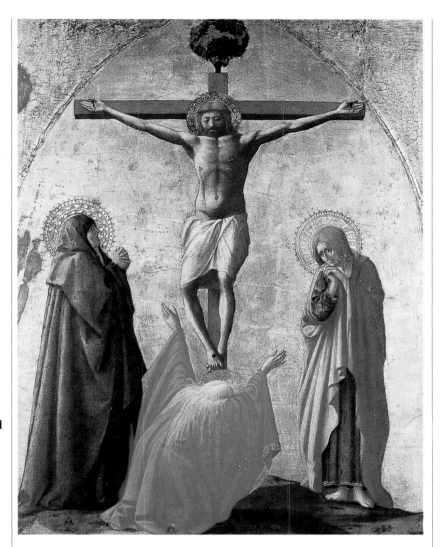

process of redemption. And therein lies the difference between this account and the traditional representations of the episode, as plainly shown by comparing it with the iconography by Agnolo Gaddi.

Masaccio studied the works of Tuscan painters, including Luca di Tommé from Siena whom he had admired in Pisa, and sculptors such as Giovanni Pisano. Clearly, he was deeply concerned with the portrayal of intense emotion and eloquent expression which are so well represented in the famous *Trinity* in the Museum of Capodimonte. The painting illustrates a silent, sacred tragedy in which Masaccio brings together an aged Virgin Mary (inspired by Antonio Gaddi's works), a miserable and dejected John, and Magdalen, daringly foreshortened and portrayed with her arms stretched open in an attempt to enclose the crucifix, which is also skilfully pictured from below. It is possible that the memory of similar paintings in the Church of the Carmine in Florence bore upon the "sacred representation" surmounting the Pisa polyptych (Brother Bartolomeo da Firenze was vice-prior of the convent in Pisa).

Generally speaking, in the *Tribute Money* the close links with the Florentine humanistic tradition seemed to have given way to a more popular interpretation of reality, in line with the view of the Carmelite Order. At this stage the process was only embryonic, but would eventually take shape in the "Carmelite" works by Filippo Lippi.

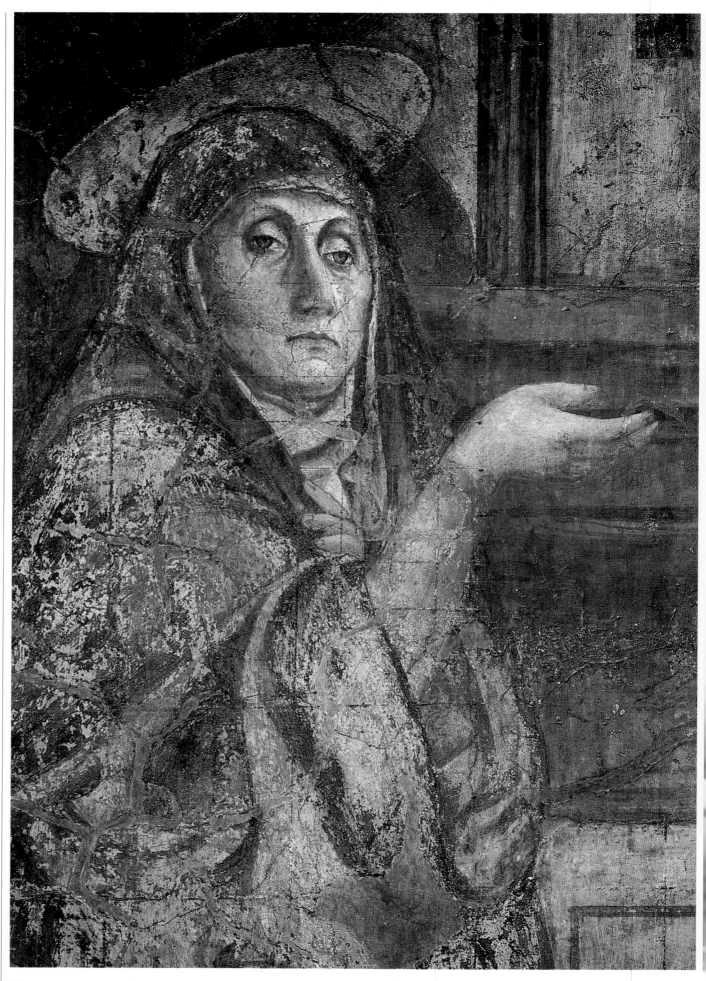

The
Masterpieces
of Maturity

Opposite:
Trinity
(1427-1428),
detail;
Florence,
Santa Maria Novella.

Here above:
Masaccio
and Filippino Lippi,
*Raising of the Son
of Theophilus and Saint
Peter Enthroned*
(1427-1428/
1484-1485),
detail
with the presumed
self-portrait
of Masaccio;
Florence,
Church
of the Carmine,
Brancacci Chapel.

AFTER RE-
suming work in the Brancacci Chapel (perhaps at the begin-
ning of 1427) Masaccio decided to depict scenes in the life of
Saint Peter with a new approach. This he did independently of
Masolino, who was compelled to return from Hungary a year
earlier owing to the sudden death of his patron Filippo Scolari.
Presumably the painting's execution was not uniform and in
some instances, as among some figures in the *Raising of the Son
of Theophilus,* there is evidence of the hand of a second painter.
Perhaps the assistant was Filippo Lippi, an artist who became
popular as one of the best followers of Masaccio's style during
the thirties. In the 1930s Brockhaus suggested that meany fres-
coes by Masaccio were removed from the lower part of the
chapel before Filippino, Filippo Lippi's son, ordered adjuncts
many years later, because they portrayed members of the Bran-
cacci family who at one stage were banished from the town.
Moreover, it is unlikely that the Carmelites decided upon a rad-
ical remake of the last part of the work, rather than opt for mi-
nor alterations to eliminate "embarassing" characters. And
there are no elements supporting the view that they would
agree on any such change. Lending support to the second in-
terpretation, a single surviving instance of *damnatio memoriae*
(public condemnation of a person and of his image and name)
carried out on one of the figures reveals the use of yet another
technique: a face in one of the paintings commissioned by Fil-
ippino has been erased to conceal the character's identity, pos-
sibly a representative of the ruling class in Florence fallen out
of favour (maybe Chancellor Bartolomeo Scala banished with
the fall of the Medicis).

The painting *Saint Peter Enthroned* corroborates the exis-
tence of a connection between the lost *Consecration of Santa
Maria del Carmine* and Masaccio's preference for portraits. In-
deed, Peter is depicted preaching in Antioch, as the Pope
would later in history, in the presence of Carmelite monks,
who act as witnesses and repositaries of their truth. There is al-
so a congregation of contemporary artists amongst which

Masaccio
and Filippino Lippi,
*Raising of the Son
of Theophilus
and Saint Peter
Enthroned*
(1427-1428/
1484-1485),
detail;
Florence,
Church
of the Carmine,
Brancacci Chapel.

Masaccio himself in what appears to be a rather plump and wan self-portrait; Masolino who owed his name to his short stature; Brunelleschi and perhaps Alberti who joined the group after his family was rehabilitated in 1428, though he often visited Florence in 1427 in the retinue of Cardinal Albergati and was hosted in the Church of Santa Maria Novella (Alberti's connection with the clergy should not be overlooked despite the lack of documentary evidence and a tendency to minimize the extent of such ties in recent studies).

The painting was recently renovated showing a glimpse of yet another character, hidden behind one of the artists and wearing a red gown: it is thought to be a portrait of Donatello, partly concealed because he appears in other illustrations of the collection. The restoration executed in the 1980s also revealed a kind of *pentimento* (although being a fresco the term is technically incorrect), in that Masaccio's hand protruded as if touching one of Peter's feet similarly to the pilgrims in the Vatican Basilica who stretch their hands to touch the bronze statue of the apostle. This aspect like several others, poses the question of Masaccio's link with Rome which, as in the case of Donatello, was established through more than one visit.

The artist worked again in the Brancacci Chapel during the last years of his activity without setting aside other commissions. Additional undated works have been dated back to this period. Firstly there is the controversial painting of the *Trinity*, a theological *manifesto* frescoed on the left aisle wall of the Church of Santa Maria Novella in Florence. The extraordinary use of perspective creates the illusion of a chapel, emulating a technique first used by Giotto in his "*trompe l'oeil* choirs" in Padua. The patron, perhaps a member of the Lenzi family, requested that self-celebrative elements be included, yet Masaccio skilfully managed to intersperse them with prevailing dogmatic features of Augustinian tradition and echoes of the Golgotha chapel. Andrea di Lazzaro Cavalcanti, adoptive son of Brunelleschi, gave this interpretation to the painting having

All paintings executed by Masaccio in the lower storey of the Brancacci Chapel display a common element of realism. The faces of those encircling the apostle in the *Raising of the Son of Theophilus and Saint Peter Enthroned* show no sign of idealization. The same is true for the Carmelite monks on the left, with their natural expressions and their features so accurately and closely depicted. Similarly the group standing on the right exhibits the portraits of contemporary characters, ranging from Masolino to Brunelleschi, and includes a self-portrait of Masaccio who painted himself with his eyes turned on the viewer.

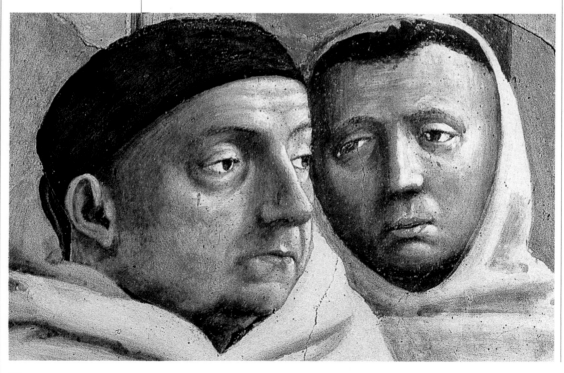

Right and here below:
Masaccio
and Filippino Lippi,
*Raising of the Son
of Theophilus
and Saint Peter
Enthroned*
(1427-1428/
1484-1485),
details;
Florence,
Church
of the Carmine,
Brancacci Chapel.

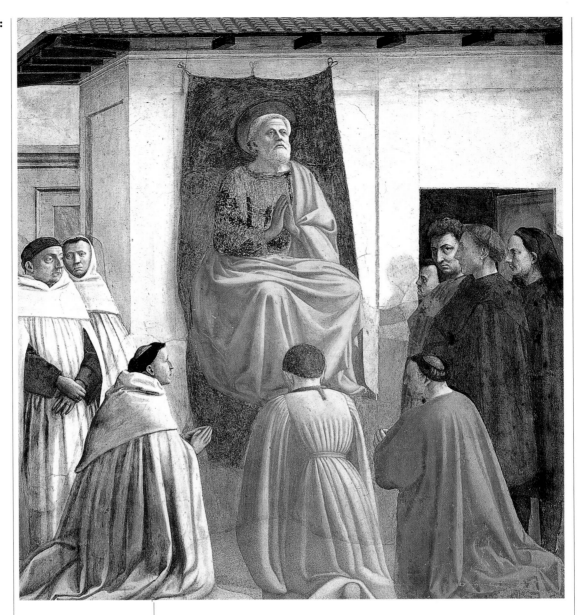

himself worked as architect and sculptor in the chapel Cardini di San Francesco in Pescia (1440-1451) also dedicated to the Trinity. Never before had perspective been applied so rigorously, manipulated so aptly to represent a dogmatic revelation or obtain the illusory effect described by Vasari in rapt admiration: «the wall seems to be hollowed out».

All together it took Masaccio thirty work sessions, the *giornate*, to paint the *Trinity* but it required a lengthy and accurate preliminary project. In the painting, mistery through scientific perspective becomes visible and takes the form of a fake altar bearing the skeleton of Adam, in itself an example of anatomical painting, and of a barrel vault chapel with coffers, framed by fluted pilaster strips. Masaccio's exploration in modern architecture, because this is what the work is also about, was greatly influenced by Donatello and Brunelleschi in a resolute attempt to assert his personal avant-garde style. There is evidence that Masaccio benefited from associating with Brunelleschi and it would be no surprise if the latter had somehow contributed to the project, but this is not documented. Over the years observers have attributed to Brunelleschi the whole architectural structure. This view appears far-fetched because,

41

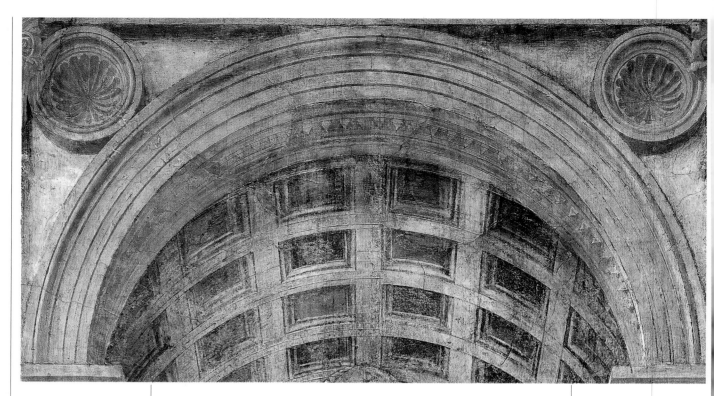

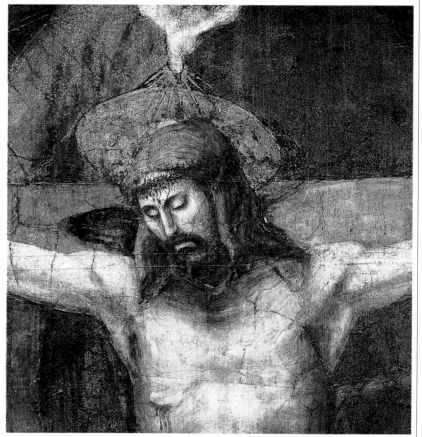

The architectural display created by Masaccio in the *Trinity* is one of the best examples of foreshortening in the history of Western painting since the classic era. Although the painting features some degree of inconsistency, as in the figures of Jesus Christ and God, which the onlooker perceives frontally owing to a lack of "appropriate foreshortening", here Masaccio distanced himself from the empirical, yet at times ingenious, solutions of previous artists. He resorted to geometry and mathematics in order to reproduce a three-dimensional reality onto a flat surface. Masaccio was not alone in the enterprise that would bring together art and science during

on the one hand, it overshadows Masaccio's own ability, on the other, it underestimates elements in the style of Donatello and Michelozzo alien to Brunelleschi's works but present in this painting. Similarities with the Barbadori Capponi chapel in the Florentine Church of Santa Felicita, which was presumibly built on a project by Brunelleschi at an indefinite date, lend no support to this view. A number of outstanding characters

the 15th century: Donatello and above all Brunelleschi achieved outstanding results in representing reality and no doubt influenced this work. However, the view that Brunelleschi painted this fresco's architectural structure, though shared by many, seems rather far-fetched. The picture of God supporting the cross with his hands follows a specific iconographic model which became popular in late 14th-century Florentine painting through a collection of works known as the "Seat of Mercy" or "Throne of Mercy". Masaccio enriches this model with new elements: for example, as in a Crucifixion he positions at Christ's feet Saint John and the Virgin Mary, whose gesture evokes the sacrifice of Jesus the Son: he paints a skeleton as a *memento mori* (an item that reminds one of the transience of life). The *Trinity* is a milestone in modern painting, in which complex theological symbolism, which has stimulated debate up to the present day, merge with elaborate formal projections.

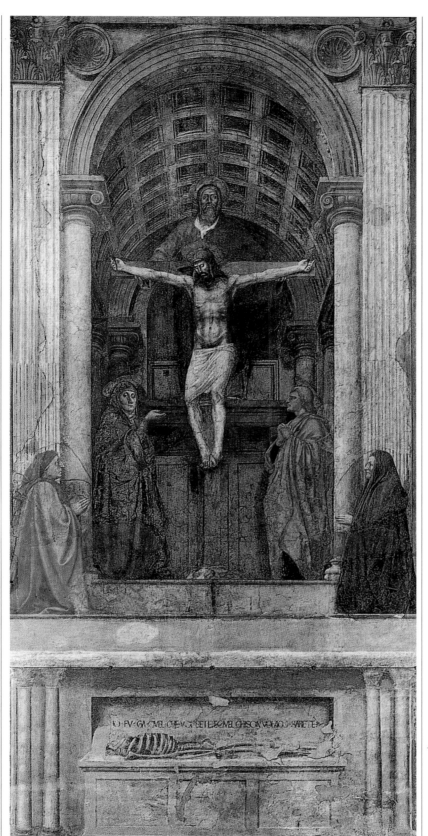

Trinity (1427-1428); Florence, Santa Maria Novella.

may have had a role in the inception of the *Trinity* such as the Dominican Alessio Strozzi di Ubaldino, expert in perspective and in touch with Brunelleschi, or young Alberti, in the retinue of Cardinal Albergati of Bologna, great peace mediator between Florence and Milan.

Although information on the *Trinity* is scarce, other late works by Masaccio, on whom, however, is available an extensive

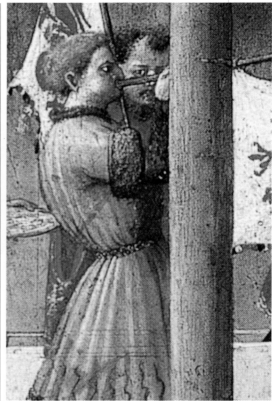

bibliography, appear less sophisticated and more in line with the taste of the bourgeois elite who commissioned the works. A Medici collection of 1492 listed under Masaccio's name a *desco da parto* of uncertain attribution, showing a "skirmish" in the style of either Scheggia, author of a desco for the birth of Lorenzo Medici, or Pesellino. The painting *Christ Exorcising a Possessed Man* that Vasari admired in the house of Ridolfo del Ghirlandaio is to date a convincing example of Andrea di Giusto's influence. Masaccio used this as a source of inspiration for many other works, amongst which the *Tribute Money* (Brunelleschi executed a silver plaquette on the same episode saved in the Louvre), and a feeble echo of an art subject he might have foreshortened experimentally. In this fresco, the temple echoing the manner of Taddeo Gaddi or the chapel Guidalotti Ruccini in the Florentine Church of Santa Croce (by Giovanni da Milano and an anonymous continuer), on top displays the dome by Brunelleschi complete with the gallery which was built on the drum well after his death.

As to this late output, the Berlin *desco da parto* is today evidence of his highly valued and striking art. On the recto there is a *Nativity*, a strongly secular representation of buglers opening celebrations for the new-born member of the seignory. The scene is set partly indoors, partly outdoors, in an structure featuring at the same time Brunelleschi's influence, elements of Masaccio's classical training and echoes of the Spedale degli Innocenti. The recto of the plate, painted on the verso probably by more than one hand, displays elaborate spatial arrangements and striking, though not always accurate, foreshortening techniques. The painting centres upon the cortège of visitors with a nun standing out against the crowd as a brilliant artifact: there are trumpet banners displaying the fleur-de-lis, visitors and the illustrious new-born in a room with heavy golden deco-

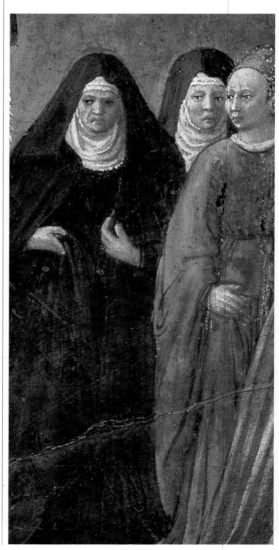

On the opposite page, from top left:
Desco da parto
(1427-1428),
recto with a *Nativity*,
full picture
and details;
Berlin,
Staatliche Museen.

Right:
Desco da parto
(1427-1428),
verso with *Putto
and a small dog*;
Berlin,
Staatliche Museen.

The *desco da parto*
was a wooden tray
used in 15th-century
Florence to carry
meals to the
puerperas.
The patron's name
remains unknown,
but as the *desco*
was a hand-painted
and decorated
luxury piece,
it was most likely
ordered
by the representative
of a Florentine
primate.
A number of details
lend support
to this theory,
such as on the recto
the picture
of buglers opening
the bearing of gifts
in honour
of the new-born,
or the fleur-de-lis
of Florence displayed
on the trumpets'
banners suggesting
that the buglers
were in the service
of the Gonfalonier
of Justice.
The interpretation
of the allegorical
child with a small
dog on the verso
to date remains
unsatisfactory.

rations which have now faded out. It is a polychrome version of Brunelleschi's architecture dazzling with dressed leather, blue-tinted vaults, marble inlays, golden mosaics, marble pillars. Masaccio's pictorial style, closer to Donatello's innovations, overcomes the tribute to Brunelleschi's modern architecture and his austere monochrome projections. Despite its uncertain date, the Berlin tondo is a good example of the Masaccio's artistic achievement in late 1427 or early 1428.

By that time his career was almost over: his journey to Rome with Masolino, who apparently never returned to Florence after his stay in Hungary, was to prove deadly. The two had been jointly commissioned an important, prestigious work on a mysterious and complex episode, which they carried out with frequent changes of mind and numerous pauses. This explains today's problems in dating the work, known as the *Santa Maria Maggiore Altarpiece*, attributed for the most part to Masolino, Masaccio having executed only the lateral panel displaying *Saints Jerome and John the Baptist*. The saints are conveyed as heroes of an "ancient" form of Christianity, their faces pictures of humanity, their feet steadily on the ground as if they were statues. The figures show a number of differences with Masolino's portraits and it is possible that attempts at reducing dissimilarities have played a role in delaying the work.

As the initial enthusiasm in the Brancacci Chapel waned off owing to unexpected problems which disheartened first one artist, then the other (provided the patron contacted Masolino on his return to Italy, which is rather unlikely), the two become engrossed with commissions in Rome.

The triptych for Santa Maria Maggiore was apparently commissioned by a prelate member of the Colonna family or a churchman close to the Pope (perhaps his nephew Prospero, who in 1426 was made cardinal *in pectore*, that is secretely) as

suggested by the many heraldic references to columns, in Italian *colonna*. Cardinal Branda da Castiglione commissioned from Masolino works in his chapel in the basilica of San Clemente. It is unknown whether the powerful advisor of Pope Martin V also commissioned from Masaccio the *Virgin and Child*, now in the Uffizi in Florence, bearing on its back the coat-of-arms of the Sienese Antonio Casini who was made cardinal in 1426 (hence the painting should be dated after this year). Moreover, it is unclear whether it was an isolated undertaking or part of a larger order. The painting, also known as the *Casini Madonna*, embodies the process whereby Masaccio incorporated in his work the Sienese tradition starting with the iconography, founded by Lorenzetti, of what Longhi termed the «Madonna del solletico». The result is a rather delicate, intimist sample of remarkable accuracy: it is hard to say whether this was the only portrait in this style or whether there were other similar works which have gone lost. Nevertheless, in Rome the names of Masaccio and Masolino seemed to have been well established because they managed to secure for themselves further work opportunities related to the Pope's desire for renovation. The two artists definitely moved to Rome in late Spring of 1428: for Masaccio it was fatal. Despite his young age he was worn and fatigued from overwork, besides being of frail constitution. There is isolated evidence, as that by the famous Palermitan humanist Antonio Beccadelli, the Panormita, that in Rome the climate was scorching and unhealthy that summer more than ever before. Masaccio died in June. At the end of the month the news of his early death reached Florence and he was struck off the tax registers. It is said that on hearing about the death of his friend Tommaso, Brunelleschi was stricken with grief and spoke these few words: «We have suffered a terrible loss». This is the well-deserved tribute paid by a great Renaissance painter to yet another outstanding artist. Almost forty years later Benedetto Dei, a merchant and chronicler in Florence, included the workshops of Masaccio's and Masolino amongst the renowned places in town (by this time Botticelli was on the scene), not wanting to forgo such celebrities. After the famous yet fleeting praise in Alberti's treatise *On Painting*, it was the first step in a process that would lend Masaccio prestige through the honourable mentions made by Landino and by Manetti, and turn him into a great Master.

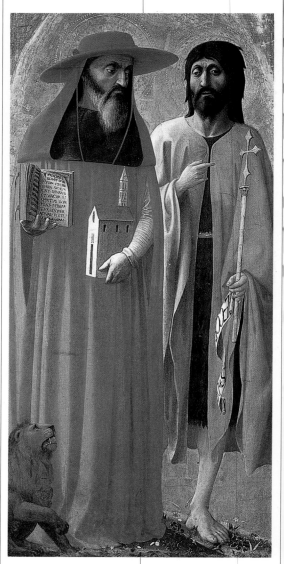

Here below and bottom: *Saint Jerome and Saint John the Baptist* (1423-1424?), compartment belonging to the dismantled *Santa Maria Maggiore*

Altarpiece by Masolino da Panicale and Masaccio, full picture and detail; London, National Gallery.

The altarpiece included six panels, today in museums in Naples, London and Philadelphia. This panel is the only one attributed to Masaccio, the others having been executed by Masolino.

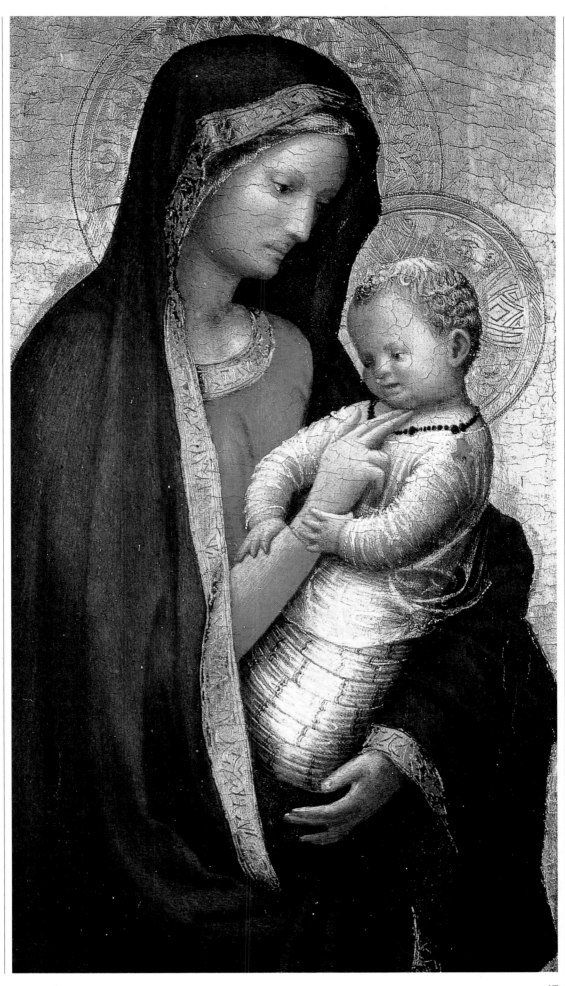

Virgin and Child
or *Madonna Casini*
(1426-1427);
Florence,
Uffizi.

**Amongst the Italian
works of art
recovered from the
Nazi regime in 1947
there was this panel
found in perfect
conditions.
On the back
one can see
the coat of arms
of Cardinal Antonio
Casini, who probably
commissioned
the work
from Masaccio,
having been
appointed in 1426.
The painting conveys
an unusual style
for the Florentine
painter, evoking
early Sienese works,
such as the
Lorenzettis',
featuring the image
of the Virgin Mary
taking care
of the Christ child
who is engaged
in spontaneous
and lively gestures.**

CHRONOLOGY

On the opposite page:
*Crucifixion of Saint Peter
and Beheading of Saint
John the Baptist,*
panel of the predella
belonging
to the dismantled
and partly lost
Pisa Altarpiece
(1426), detail;
Berlin,
Staatliche Museen.

HISTORICAL AND ARTISTIC EVENTS		THE LIFE OF MASACCIO
In Florence expulsion of aristocratic families, such as the Albertis, and opening of the contest for the execution of the baptistry doors. Gherardo Starnina goes to Spain.	**1401**	Tommaso is born in San Giovanni Valdarno. He is son of the notary Giovanni di Mone di Andreuccio and of Jacopa di Martinozzo. According to his brother, he was born on 21st December.
The Byzantine Schism comes to an end: Oddone Colonna is elected Pope (Martin V) in the city of Constance. The plague breaks out in Florence. Bernardino di Siena begins his preaching. Brunelleschi makes plans for the dome of Santa Maria del Fiore, the cathedral of Florence.	**1417**	At the end of the year he moves to Florence. His mother's second husband, Tedesco di Feo, a chemist, leaves out of his will both Tommaso and his brother, named either Vittore or Giovanni, known as "Scheggia".
The Council of Constance draws to a close. In May the Pope returns to Italy: first stops are Brescia, Pavia, Mantua. In Florence, works for the Church of Santa Trinita and Sant'Egidio are carried out. The guild Arte di Calimala undertakes to finance works for the dome of the cathedral.	**1418**	In November the death of his step-father Tedesco di Feo has already taken place. In October, Tommaso goes surety for a carpenter of San Giovanni Valdarno who joins the carpenters' guild.
In February the Pope reaches Florence. Works commence for the Spedale degli Innocenti on a project by Brunelleschi. In this year, eponym tryptich by the Master of 1419. The Painter Pietro Nelli dies.	**1419**	
The Pope raises Florence to the rank of archdiocese. Florence and Milan agree on their respective areas of influence. On 8th September consacration of the Church of Sant'Egidio in Florence. The following day the Pope leaves Florence. Bertoldo di Giovanni and Benozzo Gozzoli are born.	**1420**	
Florence buys the town of Leghorn. The offices of Consul of the Sea are created for the settlement of maritime commercial disputes. Felice Brancacci is appointed *podestà* of Pisa. Filippo Lippi takes his vows in the convent of Carmine in Florence. Andrea del Castagno is born. Nanni di Banco dies.	**1421**	Mariotto di Cristofano marries Masaccio's step-sister, Caterina. There is evidence that Masaccio's brother, lo Scheggia, is in the workshop of Bicci di Lorenzo, where Andrea di Giusto Manzini joins him at the end of the year. There is no evidence that Masaccio works there too.
Political tension between Milan and Florence. In April consacration of the Church of the Carmine in Florence. Benedetto di Maiano is born. Jacopo della Quercia works in Lucca.	**1422**	On 7th January Masaccio joins the guild known as Arte dei Medici e Speziali in Florence; he is also *pictor* for the parish of San Niccolò in Oltrarno. The *San Giovenale Triptych*, universally attributed to Masaccio, carries the date 23th April. In October he pays two liras to the guild's *camerlengo*.
Masolino paints the *Madonna* now in Brema. On 18th January he joins the painters' guild, Arte dei Medici e Speziali, one year after Masaccio. Fire in the convent of Santa Croce in Florence.	**1423**	
The plague breaks out in the area surrounding Florence. In February Florence goes to war against Milan. Braccio da Montone attacks the town of L'Aquila and the Pope excommunicates him. In July the Viscontis' troops defeat the Florentine army at Zagonara. The ducal militia enter Tuscany: Florence is dismayed and panic-stricken. Last evidence of Mariotto di Nardo's activity. Masolino is in Empoli. Dello Delli is in exile in Siena first, then in Venice, where Ghiberti goes after having worked on the baptistry doors. Dispute between Francesco d'Antonio and Masolino.	**1424**	Two of his step-sisters, Spinetta and Lisa or Ysabetta, are killed by plague. Masaccio reportedly joins a painters' guild in Florence, the Compagnia di San Luca and Masolino follows his steps by the end of the year. It is compulsory according to the guilds'reform of 1406; it is possible that the painters had to officialize their position in order to obtain some important commission, such as the *Sant'Anna metterza* for the Church of Sant'Ambrogio.
Battle of Val di Lamone between the Florentine and Viscontis' troops. Oddo da Montone, in the pay of the city of Florence, is killed. Despite their commercial rivalry, Florence forms an alliance with Venice against Milan. In May Gentile da Fabriano completes the *Quaratesi Altarpiece* and in June leaves the city of Florence. Paolo Uccello moves to Venice. Ghiberti is commissioned other doors for the baptistry. Masolino is co-painter on a sacred fresco in the Church of Carmine. Alessio Baldovinetti is born.	**1425**	Together with an elder painter, Niccolò di ser Lapo, he carries out work near the Church of Sant'Apollinare (now destroyed) in Florence: both receive money for gilding processional candelabra commissioned by the Bishop of Fiesole. In July he owes money to Bartolomeo di Lorenzo, a grocer.
The army of the league countering the Viscontis besieges the town of Brescia: Felice Brancacci is invited on the battlefield. The first payments for Masolino's work in Hungary arrive, but in December Pippo Spano dies and the contract is revoked. The nobility halts the proposal for the introduction of the cadastre.	**1426**	In February he is commissioned the *Pisa Altarpiece* in the Church of the Carmine. He receives payment up to December, despite his absence. In April he pays tax in San Giovanni Valdarno along with his brother Scheggia. In August Tommaso di Jacopo, a furrier, lists Masaccio among his debtors: to extinguish his debt the artist offers a painting of the Virgin Mary.
In May an official cadastre is established in Florence. Gentile da Fabriano and Lorenzo di Bicci die. Masolino is sued for debts, but in July he is still in Hungary.	**1427**	In January there is evidence of his presence in Pisa. In July he submits a tax return with his brother, as they live together with their mother in a rented house. He works near the Badia in Florence.
In Florence whithdrawal of the ban against the Alberti family and agreement with Milan. In Rome Poggio Bracciolini writes his *De avaritia* and in Bologna Leon Battista Alberti completes his university studies. Brunelleschi starts working in the Church of Santo Spirito in Florence; Donatello executes the *Feast of Herod* for the baptismal font in Siena; Ghiberti paints the *Sarcophagus of Martyrs Proto, Hyacinth and Nemesio.*	**1428**	After 20th June the news of his death in Rome reaches Florence. Antonio Billi's (c. 1506-1530) *Libro*, an important source of information before Vasari's book, quotes Brunelleschi's words on the event: «This is a very big loss for us». It is presumably caused «by poison». Yet, the unhealthy conditions in Rome cause thousands of deaths the summer of that same year. In his comment to Dante Alighieri's work (1481), Landino mentions that Masaccio died at the age of 27.

BIBLIOGRAPHY

Manetti A. (before 1497) "Uomini Singhularii in Firenze dal MCCC innanzi", in G. Milanesi (ed.) (1887), *Operette istoriche*, Florence, and in another edition by P. Murray (ed.) (1957), *The Burlington Magazine*, n. 99, pp. 330-336; (*c.* 1506-1542) *Il Libro di Antonio Billi* in C. Frey (ed.) (1892), Berlin; (*c.* 1537-1542) *Il Codice Magliabechiano* in C. Frey (ed.) (1892), Berlin; Vasari G. (1550 Florence and 1568 Florence) *Le Vite de' più eccellenti architetti, pittori e scultori italiani da Cimabue insino a' tempi nostri*, in G. Milanesi (ed.) (1878-1881 reprint. in 1971), Florence, Vol. II; Borghini R. (1584) *Il Riposo*, Florence; Lomazzo G. (1584) *Trattato dell'Arte della Pittura*, Milan; Bocchi F., Cinelli G. (1677) *Le bellezze della città di Firenze*, Florence; Lanzi L. (1789) *Storia pittorica dell'Italia*, Bassano del Grappa; Lastri M. (1791), *Etruria pittrice*, Florence; Crowe J.A., Cavalcaselle, G.B. (1864) *A new History of Painting in Italy*, London; von Schmarsow A. (1895-1899) *Masaccio Studien*, Kassel; Berenson B. (1896) *Florentine Painters of the Renaissance*, New York - London; Somarè E. (1924) *Masaccio*, Milan; Giglioli O.H. (1929) *Masaccio*. "Saggio di una bibliografia ragionata", *Bollettino del R. Istituto di Archeologia e Storia dell'Arte*, n. 4-5, pp. 55-101; Brockhaus H. (1939) "Die Brancacci-Kapelle in Florence", *Mitteilungen des Kunsthistorischen Instituts in Florenz*, n. 4, pp. 160-182; Lindberg H. (1931) *To the Problem of Masolino and Masaccio*, Stockholm; Procacci U. (1932) "Documenti e ricerche sopra Masaccio e la sua famiglia, *Rivista d'arte*, n. 14, pp. 489-503; "L'incendio della chiesa del Carmine del 1771", *Rivista d'arte*, n. 14, pp. 141-232; Salmi M. (1932 and 1948) *Masaccio*, Rome and Milan; Longhi R. (1940) "Fatti di Masolino e Masaccio", *Critica d'arte*, n. 25-26, pp. 145-191; Procacci U. (1951) *Tutta la pittura di Masaccio*, Milan; Berti L. (1961) "Masaccio 1422", *Commentari*, n. 2, pp. 84-107; Berti L. (1962) "Masaccio a San Giovenale a Cascia", *Acropoli*, pp. 149-165; Berti L. (1964) *Masaccio*, Milan; Vasari G. (1965) *The Lives of the Artists*, translated by G. Bull, Vol.1, Harmondsworth; Berti L., Volponi P. (1968) *L'opera completa di Masaccio*, Milan; Beck J. (1978) *Masaccio: the Documents*, Locust Valley; Baldini U. (1984) "Nuovi affreschi nella Cappella Brancacci. Masaccio e Masolino", *Critica d'arte*, n. 1, pp. 65-72; id., (1986) "Restauro nella Cappella Brancacci, primi risultati, *Critica d'arte*, n. 9, pp. 65-68; (1990) *L'età di Masaccio*, Berti L., Paolucci A. (eds.), Florence; Baldini U., Casazza O. (1990) *La Cappella Brancacci*, Milan; Joannides P. (1993) *Masaccio and Masolino. A complete Catalogue*, London; Spike J.T. (1995) *Masaccio*, Milan.

Tribute Money (1425), detail; Florence, Church of the Carmine, Brancacci Chapel.

PHOTOGRAPHS

All photographs belong to the Giunti Archive, except:
Foto Scala, pp. 14, 18.

Back numbers.
Subscription service
Tel. (+39) 0555062267
Fax (+39) 0555062287
Full Payment to be made to Art e Dossier, Florence, Italy, Post Office current account no. 12940508

Art e Dossier
Chief Editor:
Bruno Piazzesi
Periodical press:
Reg. Cancell. Trib. Firenze no. 3384 of 22.11.1985.

© 1998
Giunti Gruppo Editoriale, Firenze

Printed in Italy
Printed by Giunti,
Industrie Grafiche S.p.A.
Printing-factory of Prato

VAT paid by the publisher as laid down in Art. 74 let.c - DPR 633 of 26.10.72

ISBN 88-09-21558-3

Translation from italian by:
Christine Cesarini, Liana Longinotti